50 FINDS FROM OXFORDSHIRE
Objects from the Portable Antiquities Scheme

Anni Byard

AMBERLEY

For Mum and Dad

First published 2017

Amberley Publishing
The Hill, Stroud
Gloucestershire, GL5 4EP

www.amberley-books.com

Copyright © Anni Byard, 2017

The right of Anni Byard to be identified as the
Author of this work has been asserted in accordance
with the Copyrights, Designs and Patents Act 1988.

ISBN 978 1 4456 7074 4 (print)
ISBN 978 1 4456 7075 1 (ebook)

British Library Cataloguing in Publication Data.
A catalogue record for this book is available from
the British Library.

Typeset in 10pt on 13pt Celeste.
Origination by Amberley Publishing.
Printed in the UK.

Contents

Acknowledgements

The Oxfordshire & West Berkshire Finds Liaison Officer is hosted by Oxfordshire County Council's Museum Service at the Museums Resource Centre near Standlake, and West Berkshire Council's Heritage Service in Newbury. I would like to thank both councils for their continued support for the Portable Antiquities Scheme and for the role of FLO in our counties: Carol Anderson, Christiane Jeuckens and David Moon at Oxfordshire Museum Service; Sarah Orr; Ruth Howard and Paul James at West Berkshire Heritage. I am indebted to Oxfordshire Museum Service for allowing me to use images of their collections.

It goes without saying that this book would not have been possible were it not for the metal detectorists and other members of the public offering their finds for recording. In Oxfordshire and West Berkshire I deal with around 400 finders a year, many of whom have reported their finds for years and continue to do so, encouraging others to do the same. So, to all the finders, a special thank you for reporting your finds to me and my PAS colleagues. Even if your find doesn't appear in this book, by reporting your finds you are changing what we knew about ancient Oxfordshire, and ancient Britain, and ensuring that our history is recorded for future generations long after we are gone.

The FLO for Oxfordshire and West Berkshire works closely with local museums to facilitate the recording of finds and I would like to thank colleagues for their continued support and enthusiasm for the PAS: the Oxfordshire Museum in Woodstock; Banbury Museum; West Berkshire Museum in Newbury; and all the smaller museums who regularly put finders in touch with the FLO and who provide a vital service enabling members of the public to engage with their history.

The specialism of colleagues across the profession is invaluable and I am very grateful for their support and friendship. Thank you to Paul Booth and Oxford Archaeology; Martin Henig and Helena Hamerow of the University of Oxford; Roger M. Thomas; and Susan Lisk of Oxfordshire Historic Environment Record. The support of the Ashmolean Museum for the PAS and our monthly joint Finds ID Service has brought some amazing objects to light, and has welcomed many new finders. Thanks to Alison Roberts; Eleanor Standley; Paul Roberts and John Naylor, the National Finds Advisor for post-Roman coinage with the PAS. I am very grateful to the Ashmolean Museum for allowing me to reproduce images of objects in their collections.

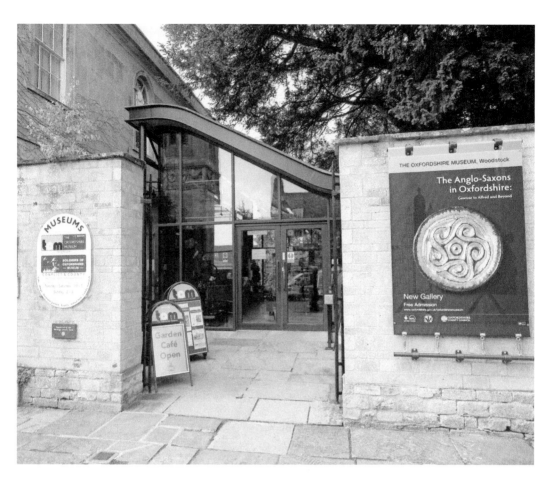

The Oxfordshire Museum, Woodstock. (A. Byard.)

The Scheme has been such a success in Oxfordshire and West Berkshire that the volume of finds offered for recording continues to increase each year. I see anywhere between 3,000 and 4,000 finds annually and without the support and enthusiasm of my volunteers I am quite sure I would have drowned under a sea of paper records. Many thanks to Rod Trevaskus, Lindsey Smith, and to my father, Michael Byard, who regularly enters all the large rally records.

My colleagues across the PAS are always an invaluable source of support and knowledge. In particular I would like to thank Michael Lewis, Claire Costin, Mary Chester-Kadwell and Ian Richardson at the British Museum, and Roger Bland who had the foresight to set up the PAS. The National Finds Advisors provide a vital service with very limited time and resources; Kevin Leahy, Sally Worrell, Sam Moorhead, Andrew Brown and John Naylor. To all my FLO colleagues in surrounding counties and further afield, thanks for your continued support and friendship. A big thank you also to Paul Otter and Toby for their support, assistance and good humour, and to Jonathan Baker for comments on the draft. Finally thanks to Connor Stait and Amberley Publishing for allowing me to indulge my passion for archaeology and writing.

Some of the descriptions of the fifty finds are based on database records written by colleagues; they are credited in the database records but are thanked again here without being individually named. A number of images used in this book have been produced by others and these people are credited in the captions. Most of the images of finds are from the PAS. Every attempt has been made to obtain permission for copyrighted material used in this book. However, if I have inadvertently used copyrighted material without permission or acknowledgement I apologise and will make the necessary corrections at the first opportunity. As is usual, any other errors remain my own.

Anni Byard

Foreword

The places in which we live and work have a long past, but one that is not always obvious in the landscape around us. This is a forgotten past. Most of us know little about the people who once lived in our communities 50 years ago, let alone 500, or even 5,000 years past. Like us, they lived, played and worked here, in this place, but we know almost nothing of them.

History books tell us about royalty, aristocrats and important churchmen, but most others are forgotten by time. The only evidence for many of these people is the objects that they left behind; sometimes buried on purpose, but more often than not lost by chance. Occasionally, through archaeological fieldwork, we can place these objects in a context that allows us to better understand the past, but nowadays excavation is mostly development-led, and so only takes place when a new building, road or service pipe is being constructed.

A unique way of understanding the past is through the finds recorded through the Portable Antiquities Scheme, of which those chosen here by Anni Byard (Oxfordshire and West Berkshire Finds Liaison Officer) are just 50 of over 30,000 from Oxfordshire on its database (www.finds.org.uk). These finds are all discovered by the public, mostly by metal-detector users searching in places archaeologists are unlikely to go or otherwise excavate. As such they provide important clues of underlying archaeology that, once recorded, help archaeologists understand our past – a past of the people, found by the people.

Some of these finds are truly magnificent, others less imposing. Yet, like pieces in a jigsaw puzzle, they are often meaningless alone, but once placed together paint a picture. These finds, therefore, allow us to understand the story of people who once lived here, in Oxfordshire.

Dr Michael Lewis
Head of Portable Antiquities & Treasure
British Museum

Introduction

Since its inception in 1997, the Portable Antiquities Scheme (PAS) has recorded around 1.3 million objects found by members of the public throughout England and Wales. Most of these artefacts have been found by metal detector users. Gardeners and walkers have also contributed to the Scheme. Artefacts are recorded on the freely accessible PAS website (www.finds.org.uk/database). The data is used by both amateur and professional researchers, metal detectorists, local history groups and schools using PAS images to illustrate the history curriculum. PAS data is frequently used by university students and academics in their research.

The PAS works through a network of Finds Liaison Officers (FLOs) who regularly attend metal detecting club meetings and hold museum drop-in surgeries, where finders of archaeological artefacts over 300 years old can submit their finds for identification and recording. Once recorded, the objects are then returned to the finder.

The PAS first came to Oxfordshire in 2004 and is hosted by Oxfordshire County Council's Museum Service. In that time, over 30,000 artefacts spanning a period of around 450,000 years have been offered for recording. While there are some spectacular finds from the county,

Eighty-eight-year-old metal detectorist Stan Barker with a Roman brooch. (Clint Barker. Reproduced with kind permission.)

the vast majority are the more mundane and everyday artefacts that have been lost by their owners, only to be found hundreds, if not thousands, of years later. Roman coins are very common throughout the fields of Oxfordshire, while Roman brooches, medieval silver coins, belt buckles and strap fittings and other items of personal dress are also common. The array of artefact types is quite staggering, and not all of them are made from metal. The PAS encourages metal detectorists to look for prehistoric flint tools and pottery while out in the fields.

Recording is voluntary, apart from certain classes of objects that are covered under the Treasure Act 1996, for which all qualifying discoveries must be reported to the Coroner within fourteen days. There are several criteria for what constitutes 'Treasure': any object over 300 years old that contains more than 10 per cent precious metal (gold or silver) by weight and objects of prehistoric date (i.e. pre-Roman) would be treasure if any part of it contains precious metal, or if there are two or more copper-alloy (i.e. bronze) objects from the same findspot. Coins are different; a single gold or silver coin over 300 years old would not be considered treasure (and we encourage finders to report these single finds), whereas two or more gold or silver coins, or over ten copper-alloy coins from the same findspot, could be considered treasure and require reporting. The old law of 'Treasure Trove' now mostly concerns precious metal finds under 300 years old hidden with the intention of recovery. The FLOs and the PAS facilitate and administer the Treasure Act on behalf of the government. Any individual can report treasure to the Coroner, but most finders report their objects to the FLO, who then reports to the Coroner on the finder's behalf. More information about Treasure can be found on the PAS website (www.finds.org.uk/treasure) or by contacting the local Finds Liaison Officer.

The recording of artefacts has transformed our knowledge and understanding of the past and the people that inhabited our local and national landscape. Certain objects may identify a local tribe, a social status, or highlight religious practices and beliefs. Looking at whole artefact assemblages can literally transform the known archaeology of an area overnight. This happened in Oxfordshire in 2009 and 2010 when over 1,200 metal detectorists descended on land near West Hanney, in the Vale of the White Horse, for large, organised commercial 'rallies'. Although rallies are controversial, over the equivalent of four days around 1,200 objects were recorded, transforming the known archaeological activity of that parish overnight.

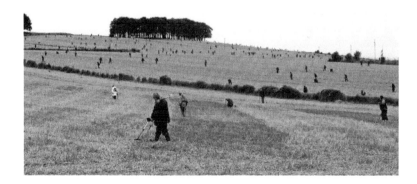

A large metal detecting rally near Childrey. (A. Byard.)

Sadly there are people who use metal detectors for illegal purposes to 'raid' sites, often at night, in an attempt to recover artefacts to sell on the black market. This practice is known as 'nighthawking' and, unfortunately, because of the archaeological richness and rural nature of our county, Oxfordshire has its fair share of criminal metal detecting. It is against the law to metal detect on protected archaeological sites (Scheduled Monuments), Sites of Special Scientific Interest (SSSIs) and some other designated areas. One must *always* have permission to detect as every single piece of land is owned by someone, even the local park. By detecting on land without permission, one could be charged with trespassing, criminal damage and theft, face an unlimited fine, and spend up to three months in prison. The PAS works with the police, Historic England and landowners to gather evidence of nighthawking and other illegal activities related to metal detecting. Because of the trust built between bona fide detectorists and the PAS over the past twenty years, it is often other detector users themselves that report illegal or suspicious activity.

By working together and encouraging others to report their archaeological finds we can change the understanding of our past. Recording allows members of the public to contribute to the understanding of our shared heritage.

In this, the twentieth year of the PAS and the instigation of the Treasure Act, I am delighted to present my personal selection of the 50 best finds from Oxfordshire. It was not an easy choice – with over 30,000 artefacts to choose from, this could be the first of many books highlighting the contribution the public have made to the understanding of the archaeology of this county.

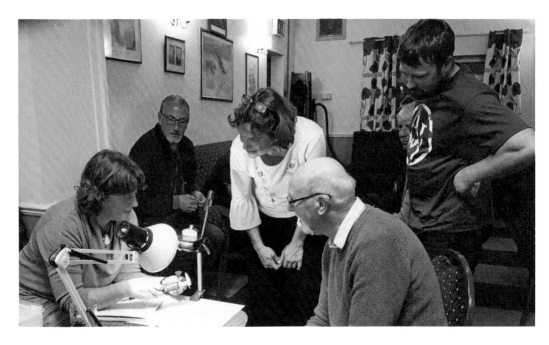

The author recording finds with members of the Oxford Blues Metal Detecting Club. (Rob Wadley. Reproduced with kind permission.)

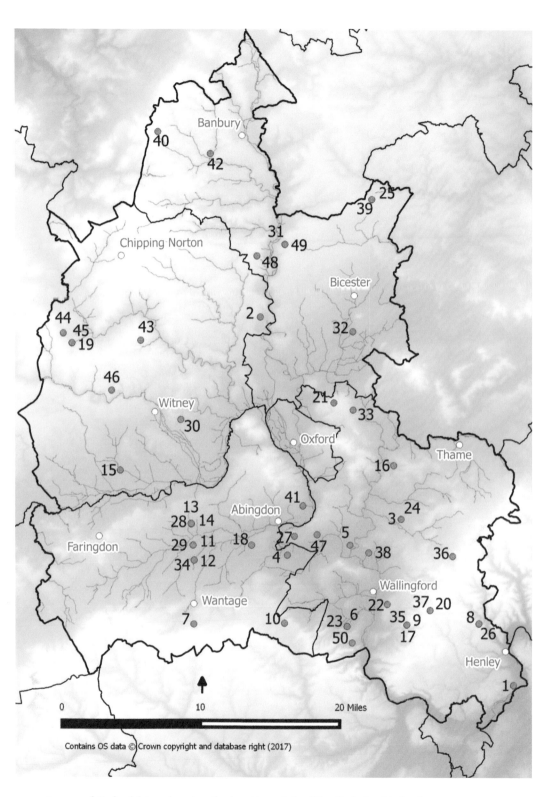

A map of Oxfordshire, showing the location of the fifty finds in this book.

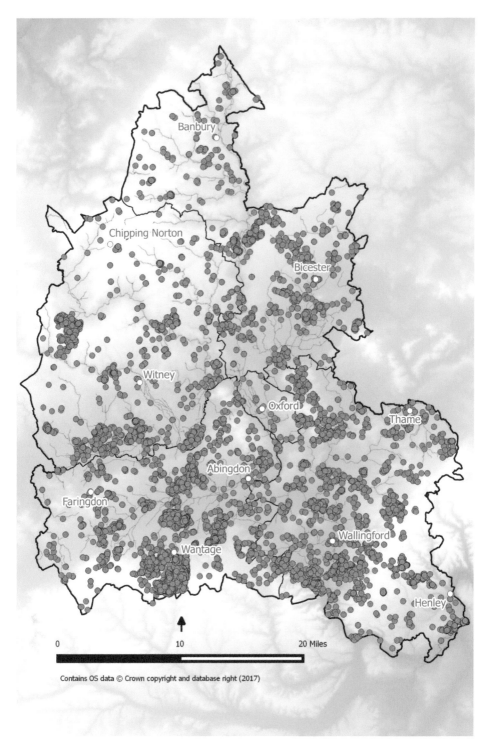

A map of all PAS finds from Oxfordshire. The large concentrations show the locations of rallies.

Chapter 1
The Oxfordshire Landscape

Oxfordshire is a rural county covering approximately 756 square miles (2,000 square km). Its boundaries were redefined in 1974 to include parts of northern Berkshire south of the Thames, now the Vale of the White Horse, and parts of South Oxfordshire. In its current form the county is bounded to the south by the Ridgeway ancient track and the Berkshire Downs, to the east by the Chiltern Hills, and to the north by the rolling hills of the Cotswolds. Geologically the county is diverse, with several distinct bands running across the county. From the north of the county down to the Vale are alternating bands of clay and limestone. A band of sand underlies Wantage, Didcot and Wallingford, which gives way to a band of chalk across the Downs and Chilterns. These geological strata, which formed millions of years ago in the shallow sea that covered the county, influence the topography, soil type and, ultimately, the character of the landscape, natural and man-made.

The county is dominated by the River Thames and its floodplains; the river meandering from the western side of the county, curving up beneath Oxford and then dropping south-eastwards to Goring Gap. The Thames is fed by several large tributaries from across the county; the Cherwell, Evenlode, Windrush, Ock and Thame, and many smaller streams.

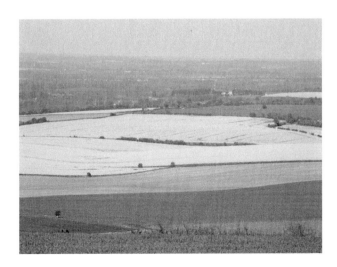

Looking north from the Ridgeway across the Vale of the White Horse. (A. Byard.)

These river valleys define Oxfordshire as a mostly level county, with the highest point being Whitehorse Hill in the Vale of the White Horse (261 m).

The fertile Thames floodplain and the river valleys of its tributaries have attracted and defined settlement location for millennia. Extensive studies have been undertaken on the archaeology of the river gravels of the Upper Thames Valley. The fertility of the county provided ample agricultural produce – a defining characteristic of the county until relatively recently. By the fourteenth century, Oxfordshire was one of the wealthiest counties in the country.

The agricultural background of the county means that archaeological artefacts are commonly discovered in our modern fields. The PAS has recorded artefacts from every area of Oxfordshire, with the majority coming from the Vale and South Oxfordshire. There is a bias here, as the two districts have attracted many metal detecting rallies over the years and are predominantly arable. The quantity of finds from Cherwell and West Oxfordshire, by no means insignificant, is a reflection of not only metal detecting biases (availability of land), but also of the historic land use, with pasture land being historically more common than arable. Although a generalisation, more metal artefacts do appear to be found on historically arable land than pasture.

Typical river valley and rolling hills of the western side of the county. (A. Byard.)

The River Thames at Clifton Hampden. (Paul Otter.)

Chapter 2
The Stone Age (700,000–2400 BC)

The use of stone tools was the predominant technology of early prehistory. In Britain the period covers nearly 700,000 years and is split into three main periods: the Palaeolithic, Mesolithic and Neolithic. The Palaeolithic (Old Stone Age) is divided further into three phases due of the vast amount of time it covers: the Lower Palaeolithic (the earliest period, c. 800,000–150,000 BC), Middle Palaeolithic (c. 150,000–40,000 BC) and Upper Palaeolithic (c. 40,000–10,000 BC). This division is based on climatic and environmental factors and, archaeologically, it represents changing technology in the manufacture and production of stone tools.

The Palaeolithic landscape would have been almost unrecognisable to modern eyes. When not covered in vast ice sheets, the landscape was mostly grassland with few trees. Large animals such as mammoth, elk and woolly rhinoceros roamed the land. During periods of glaciation Britain was connected to mainland Europe by a land-bridge, which enabled animals and early humans (*Homo antecessor* and *Homo heidelbergensis*) to visit periodically. The climate varied from very cold glacial episodes with Arctic temperatures to warmer periods (interglacials). Early human occupation would have been limited to the warmer periods, when woodland expanded and a wider range of flora and fauna was available. Neanderthals (*Homo neanderthalensis*) first came to Britain around 60,000 BC and modern humans (*Homo sapiens sapiens*) after 40,000 BC. Occupation didn't become permanent until after the last Ice Age, about 12,000 years ago.

The Palaeolithic is first evident in Oxfordshire around 475,000 BC. Some of the earliest sites in the county have been discovered as a result of gravel extraction, for example at Wolvercote, Stanton Harcourt, Crowmarsh and Goring. While Palaeolithic finds are by no means common, of the forty objects recorded by the PAS from Oxfordshire ten are hand axes. All the hand axes are from unstratified contexts, so rather than being evidence of occupation they represent a more general presence of human activity during the period. As the name suggests, these tools were designed to be used in the hand and were not hafted to a wooden or bone handle.

This is one of the earliest objects recorded by the PAS, a sub-cordate hand axe from Kidmore End, dating from the Anglian phase of the Lower Palaeolithic, between around 478,000 and 423,000 years ago. The hand axe has bifacial (double-sided) removals which were made using a hard hammer, such as another stone. Although the hand axe has some post-depositional damage and iron staining, it survives in very good condition; the technology used to produce this hand axe is one of the earliest known. Based on the location of discovery, this hand axe probably derived from the Caversham Channel, an ancient route of what is now the River Thames. (Alison Roberts, Ashmolean Museum, pers. comm.)

A slightly later hand axe from Abingdon dates to the Acheulean phase, around 340,000–300,000 BC or 245,000–190,000 BC (depending on which gravels it came from). This example was found during building work in a garden, showing that even very early objects can be found in the most unexpected of places.

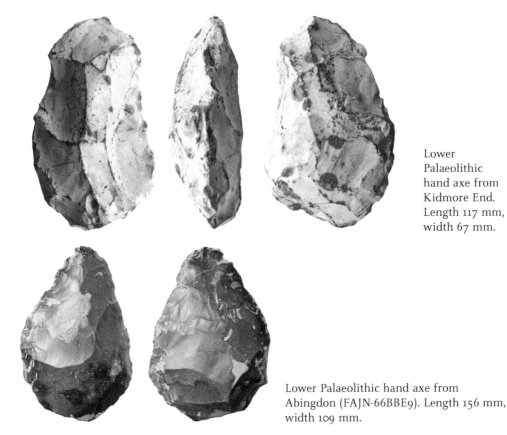

Lower Palaeolithic hand axe from Kidmore End. Length 117 mm, width 67 mm.

Lower Palaeolithic hand axe from Abingdon (FAJN-66BBE9). Length 156 mm, width 109 mm.

At the end of the last Ice Age, about 12,000 years ago, small groups of modern humans had to adapt to a changing environment. During the Mesolithic (Middle Stone Age) period the English Channel was formed, cutting Britain off from mainland Europe. The landscape would have been one of extensive woodlands and related flora and fauna, such as beavers, deer and pigs.

Although axes are still common, small, sometimes tiny blades called microliths are characteristic of the Mesolithic period. These can be very difficult to spot on the ground, especially if the area is already rich with flint. However, once located they are easily identified. Microliths were probably used in hunting and gathering activities and would have been hafted into wood or bone using tree resin as glue.

These microliths from Tackley form part of a much larger group of multi-period flint artefacts, collected in the nineteenth century by Tackley antiquarian Mr Evett. Over 800 flint artefacts from this collection have been identified and recorded with the PAS. Some rather dubious-looking artefacts in the collection led to the revelation that Mr Evett financially rewarded finders of flint objects with a penny or two, so the enterprising locals tried their hand at flint knapping; these objects have become artefacts in their own right.

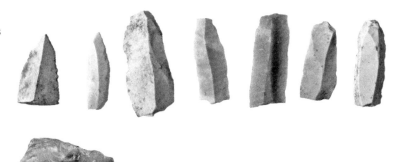

Mesolithic microliths from Tackley, 15 to 22 mm in length. (Evett Antiquarian Collection, courtesy of Tackley Local History Group.)

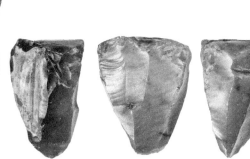

Mesolithic bladelet core from Lincolnshire showing the long, thin removals characteristic of microliths. (NLM-ADE588)

17

Alison Roberts of the Ashmolean Museum identifying and recording flint tools from the Evett Antiquarian Collection. (A. Byard.)

This late Mesolithic to early Neolithic adze from Chalgrove has a distinctive flake removal across its tip, giving the tool its name. This tool was probably used for working cut wood as well as for chopping. The tools used by Mesolithic people reflected their hunter-gatherer lifestyle, with new tool types continuing to emerge, including blades and knives, scrapers and awls.

The adze survives in very good condition with no notable modern damage, which often happens as objects are moved around by the plough.

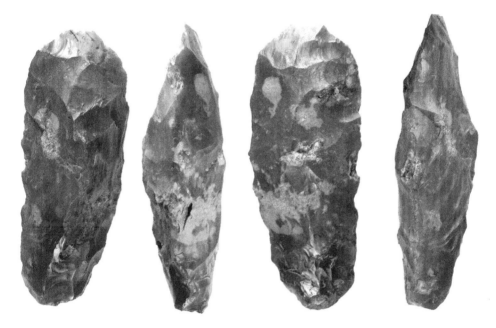

Mesolithic tranchet adze from Chalgrove. Length 125 mm, width 47 mm.

4. Polished axe from Sutton Courtenay (BERK-796456)
Neolithic (c. 4,000–2,400 BC)

The Neolithic (New Stone Age) period was revolutionary in human cultural development. For the first time crops were planted and animal husbandry developed. Huge areas of woodland were cleared to make way for agriculture. Human groups, who until this period were fully or semi-nomadic, settled into a more sedentary domestic regime. Evidence for Neolithic habitation and activity is widespread across Oxfordshire; ritual monuments like stone circles, burial mounds and causewayed enclosures are seen for the first time as society became culturally and politically complex. With the transition to sedentism came advances in technology, including the introduction of pottery. Flint tool kits were extensive and specialised artefacts become normal. The quality of flint and stone tools is arguably at its most aesthetic during the Neolithic period.

A polished axe found at Sutton Courtenay is made from a metamorphic rock, probably not sourced from Oxfordshire. Polished axes are typically Neolithic and were produced by grinding the surface of the stone with another rock to produce a smooth surface. Because there were fewer facets than knapped examples, these axes were less likely to break during use. There are some flaws on the surface of the Sutton Courtenay axe that have been partially polished out. Polished axes' pleasing appearance played a symbolic and ritual role in Neolithic society; they were prestigious items to own. Demand for polished axes led to the development of an industry specialising in their production, with sources for the raw materials known from Ireland, North Wales and from the axe 'factory' at Great Langdale in the Lake District.

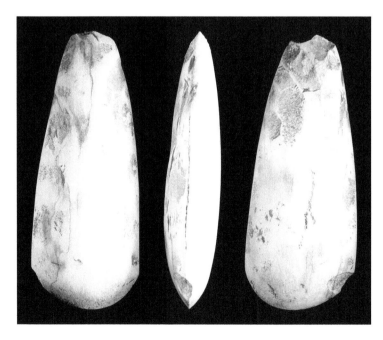

Polished flint axe from Sutton Courtenay, 185 mm in length.

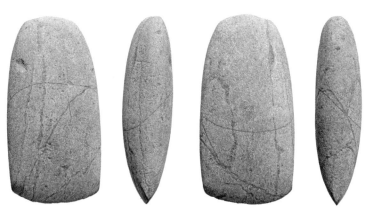

Greenstone polished axe found in a Witney garden, 132 mm in length. This axe is probably from the Langdale axe factory. (BERK-8CD431)

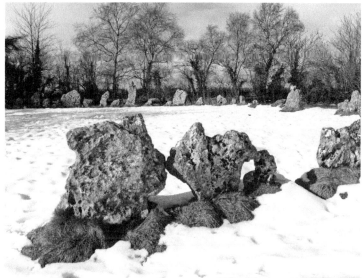

The Neolithic Rollright Stones near Chipping Norton. (George Lambrick. Reproduced with kind permission of the Rollright Trust.)

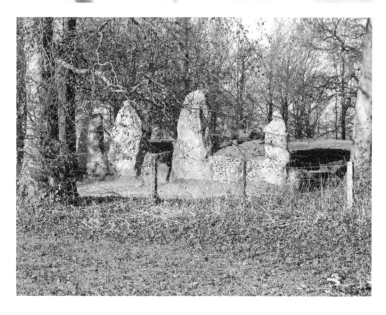

Wayland's Smithy Neolithic chambered long barrow near Uffington White Horse. (Paul Otter. Reproduced by kind permission of the National Trust.)

As the Stone Age slowly gives way to the age of metal, flint continues to be used for tools and weapons. Spanning the two periods are barbed and tanged arrowheads, some of which are so finely made they may have been prized possessions rather than functional objects. This wonderful example from Dorchester may be an example of a prestige object. The arrowhead is long and slender and although the tip of the arrowhead is missing, it is a very well made object. Arrowheads of this type are not a common find; more usually, they are short and squat.

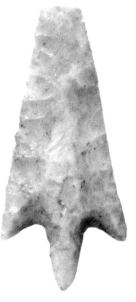

Barbed and tanged arrowhead from Dorchester, 36 mm in length.

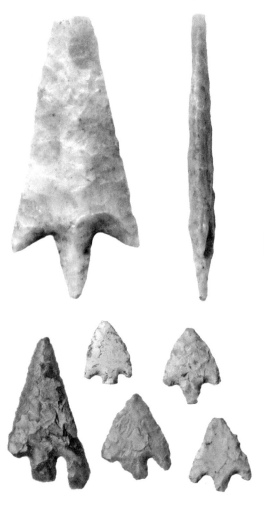

The more typical form of barbed and tanged arrowheads. (BERK-07AD95) (Evett Antiquarian Collection, courtesy of Tackley Local History Group.)

Chapter 3
The Bronze Age (c. 2400–800 BC)

Although flint continues to be used for objects like arrowheads until around 1,500 BC, the quality of flint working declines and objects that were once made of stone start to be made of bronze. Evidence of bronze working is sometimes reported by detectorists but as these are generally amorphous lumps of bronze, they can go unrecognised. Axes are the first types of objects to be made in this new material, but very soon spearheads, arrowheads, swords, razors, daggers, dress pins and small tools like awls are produced. Gold appears for the first time around 2,400 BC.

Many Bronze Age finds are broken and very fragmentary, possibly being discarded after they broke or having been damaged by recent agricultural activity. Bronze was a precious and prestigious commodity and much of it would have been melted down for reuse; the presence of both complete and fragmentary objects as well as casting waste in 'founder's hoards' attests to this practice.

Recently Oxfordshire has produced a wide range of Bronze Age metalwork in very good condition. Several commercial metal detecting rallies in the area between Radcot and Bampton, to the north of the Thames, has yielded a good number of well-preserved artefacts of Bronze Age date. Recording the finds with the PAS with accurate findspot information has led to the recognition of a previously unrecognised landscape rich in Bronze Age finds. A similar landscape has also recently been identified near Kingston Bagpuize. These objects were probably ritually deposited in or near bodies of water – an occurrence seen across Britain during this period.

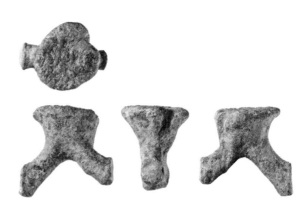

A Bronze Age casting jet from Tetsworth. (BH-CC49D5)

6. Gold 'basket' ornament from Cholsey (BERK-0D1A05)
Early Bronze Age (c. 2,400–2,200 BC)

This class of object is very rare and dates to the earliest phase of metallurgy in Britain. Such objects are variously referred to as 'basket ornaments', 'basket earrings', or 'hair rings'. They are personal ornaments and, whether worn in hair, the ears or with items of dress, they were rolled into a basket shape when in use. When first found, this object appeared to be just a crushed piece of gold-coloured foil, but when the metal detectorist unfolded the item at home he realised he was looking at a very rare object and reported it to the PAS. Basket ornaments are generally found in pairs and are associated with graves, but the number of singular examples now recorded suggests that there was some element of re-use away from a funerary context.

Weighing only 1.5 grams, metallurgical analysis on the Cholsey ornament revealed a gold content of nearly 92 per cent. Two similar objects were excavated from the Barrow Hills site at Radley and are now in the Ashmolean Museum (accession number AN1944.122.a-b). Another was recently discovered by Oxford Archaeology at Tubney Quarry.

Because this object is of precious metal and of prehistoric date, it meets the criteria of the Treasure Act 1996. After the finder and landowner were rewarded, it was purchased by Oxfordshire County Museum Service.

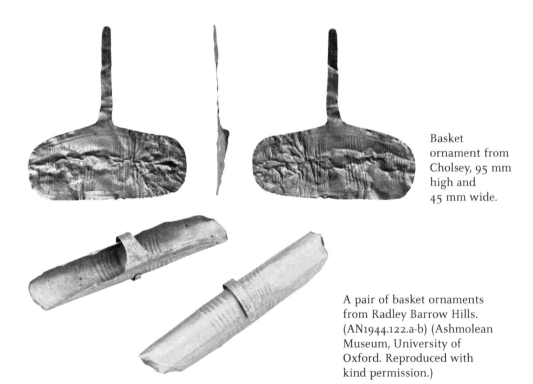

Basket ornament from Cholsey, 95 mm high and 45 mm wide.

A pair of basket ornaments from Radley Barrow Hills. (AN1944.122.a-b) (Ashmolean Museum, University of Oxford. Reproduced with kind permission.)

This small but complete cast-alloy flat axe is one of the earliest artefacts to be made in this metal. It was probably used for wood working rather than felling trees. The axe is decorated with punched pellet panels on both sides and is very similar to a number of decorated examples of the 'Brandon' type. Decorated flat axes are characteristic of Irish examples but there is no direct parallel for the decoration on the Wantage flat axe.

As the Bronze Age continues, axes become more complex, with palstave axes developing in the Middle Bronze Age (*c.* 1,500–1,150 BC) and socketed axes in the Late Bronze Age and Early Iron Age (*c.* 1,150–700 BC).

Right: Decorated flat axe from Wantage, 78 mm in length.

Below left: Middle Bronze Age palstave axe head from Bampton, 144 mm in length. (BERK-CD4525)

Below right: Late Bronze Age socketed axe head from Grafton and Radcot, 81 mm in length. (WILT-A30E3C)

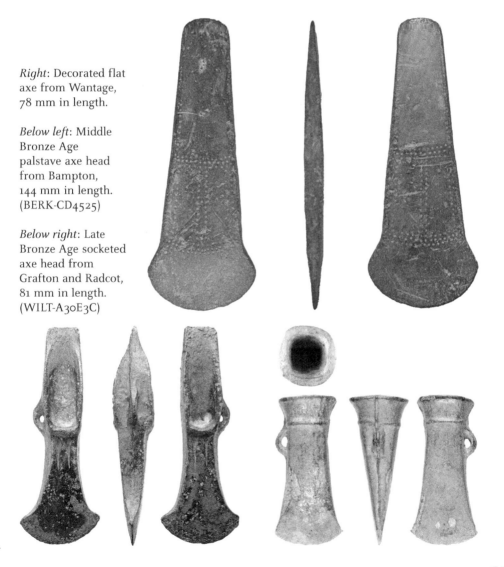

In some parts of Britain Bronze Age hoards are not uncommon, but this is not the case in Oxfordshire. The first Middle Bronze Age metalwork hoard was found at Bix, near Henley, in 2015. Small fragments and one complete bracelet were found in a small area and once the detectorist identified an *in situ* concentration he stopped digging and contacted the FLO. Excavation revealed a collection of artefacts buried in a ceramic pot, which had been badly damaged by ploughing. The hoard comprised nineteen complete and partial objects in over eighty-five pieces and included dress or hair pins, broken rapier blades, spiral torc fragments, a complete, decorated bracelet, and two razors – one of which was intricately incised with geometric patterns. The hoard belongs to a period known as the 'Ornament Horizon', when we see items of personal adornment in bronze for the first time. Both the bracelet and decorated razor are rare objects, but their presence along with partial or broken objects suggests they were intended to be melted down.

As these objects are over 300 years old, from the same findspot and of prehistoric date, they qualify under the Treasure Act 1996. Oxfordshire County Museum Service hopes to acquire to collection.

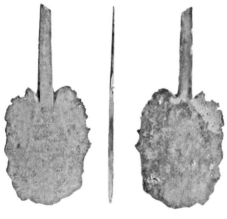

Above left and right: Decorated razor and bracelet from the Bix hoard; razor's length is 39 mm while the bracelet's internal diameter is 56 mm.

Left: Part of the Bix 'Ornament Horizon' hoard, *c.* 1400–1200 BC.

This lovely spearhead was found by an eleven-year-old boy on his first metal detecting outing with his grandfather. It is a very fine example of a decorated leaf-shaped socketed spearhead dating to the final phase of the Bronze Age. Found point-down, this spearhead may have been a purposeful deposit rather than a casual loss. The edges of the blade are still sharp and there is only a small area of damage to the socket. The silvery appearance of the metal shows that the alloy used to make the bronze has a high tin content. A small number of similar examples are known, with one similarly decorated object being found with the Reach Fen hoard (Cambridgeshire). Of examples from the Oxfordshire/Berkshire area, three with similar decoration are known from Culham, Oxon, Maidenhead, Berks (closest to the Wallingford example in decoration) and from Windsor, Berks.

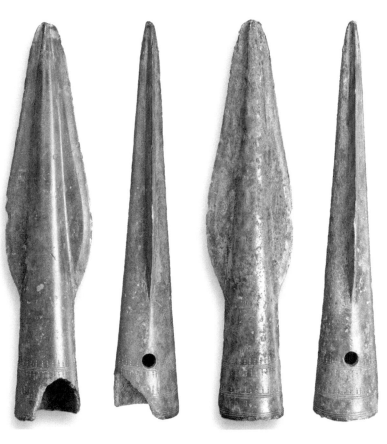

Late Bronze Age decorated spearhead from near Wallingford, 134 mm in length. (Magdalena Wachnik, Oxfordshire Museum Service/Portable Antiquities Scheme.)

10. Socketed axe mould and axes from Upton (BERK-56BD17)
Late Bronze Age (*c.* 1,000–800 BC).

This nationally important find was seen for sale in an antiques shop near Chipping Norton. Allegedly discovered during the late 1980s – before such objects were classed as 'Treasure' – and previously unseen by archaeologists, the dealer knew the provenance of the find and allowed the hoard to be recorded. The hoard comprises an extremely rare copper-alloy axe mould, three copper-alloy socketed axe heads and six pieces of bronze metalworking casting debris. The axe heads are of a type dated to the Ewart Park Phase of metalworking, around 1000–800 BC. The three axes are all identical to each other and to the form, size and shape of the mould, showing that the mould was used for their casting. The mould has a tongue and groove design around the edge, allowing the two pieces to be slotted together during casting. The remains of a failed axe casting can be seen in the upper portion of one half of the mould (pale white-yellow in colour).

A second axe mould, this time for a palstave axe, has recently been discovered near Chinnor and is currently going through the Treasure process (two or more objects of base metal of prehistoric date are now considered to be Treasure under the 2003 amendments to the Treasure Act 1996). In this case, the finder realised the importance of his discovery, stopped digging and reported it immediately. The quick thinking of the detectorist has secured the archaeological context of the find and it is hoped that much important information can be gleaned from its examination – of the fifty or sixty Bronze Age moulds discovered, only a small number have been associated with any archaeological features.

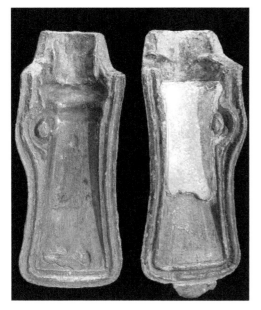

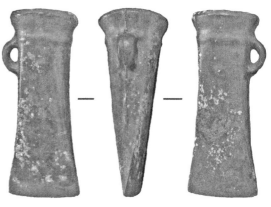

Above: One of three identical socketed axes from the Upton hoard, cast in the mould pictured left.

Left: Socketed axe mould from Upton, 151 mm long and 64 mm wide.

Chapter 4
The Iron Age (*c.* 800 BC to AD 43)

Like previous periods, the Iron Age is split in to three phases: Early (*c.* 800–400 BC), Middle (*c.* 400–100 BC) and Late (*c.* 100 BC–AD 43). In Britain, the Iron Age came to an end with the Roman invasion by Claudius in AD 43.

Although bronze was still used for many personal and everyday objects, iron became the metal of choice for tools and weapons. Iron weapons and tools are not common finds; detectorists generally discriminate iron in their searching because of the sheer quantity of relatively modern nails and other iron fragments in the fields. Because of this bias, most of the metalwork of this period recorded with the PAS is of copper alloy.

Iron Age people lived in small communities in characteristic roundhouses, and would have grown their own crops and looked after animals such as pigs, sheep and cattle, which were used for food as well as a secondary products (such as wool and milk). Hillforts, like those of Castle Hill at Wittenham Clumps near Wallingford, and Segsbury Camp near Wantage, were defended enclosures, stockades and gathering places that were built from the Late Bronze Age and Early Iron Age.

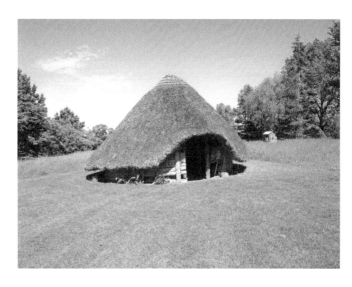

A typical Iron Age roundhouse, constructed in the 1980s. (A. Byard. Reproduced by kind permission of the Earth Trust.)

As the Iron Age progresses we see a marked increase in the range of objects being produced locally and imported. A distinctive art style develops across Britain and Europe and all manner of goods and commodities, both essential and prestige items, are being traded widely. The term 'Celt' or 'Celtic' is often used to described this period and its people but the term was one used by Greek and Roman writers to describe whole swathes of people who lived to the west. During the Iron Age there was no unified political identity and people would have instead identified with a local or regional group or tribe. By the later Iron Age we know that what was to become Oxfordshire was inhabited by at least three tribal groups: the Atrebates in the south, the Dobunni in the north-west and the Catuvellauni in the north-east.

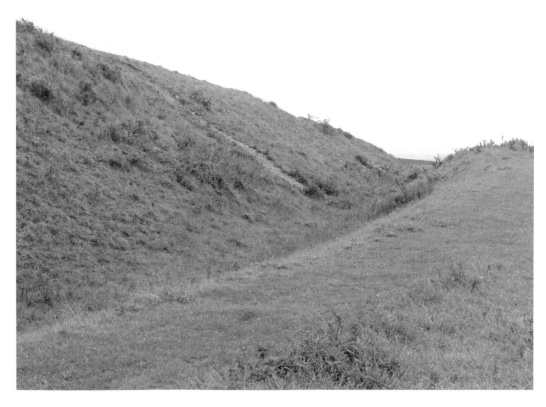

Part of the Iron Age ditch of the hillfort at Wittenham Clumps. (Paul Otter. Reproduced by kind permission of the Earth Trust.)

From the Late Bronze Age/Early Iron Age, we see an increase in dress accessories made from non-ferrous metals. Recently, several of these rare 'swan-neck' pins have been found across Oxfordshire, but this example from Lyford is notable for its small size. Formed from a single rod of copper alloy, the head section has been twisted to form a spiralling rod before it was bent round to form a ring or loop. Below the head of the pin is the swan-neck curve, seen on many pins of Iron Age date. The shank of the pin tapers to a sharp point but is very short – other pins have much longer shanks and it seems likely that the Lyford pin has been reused or mended. Swan-neck pins belong to a broader group of ring-headed pins in use throughout the Iron Age in England and Ireland. Their exact function is unknown; they are rarely found in graves and don't appear to be sex specific. They were probably used to secure clothing or may have been worn in the hair. Unfortunately, the 'swan-neck' has no firm chronological significance and appears on pins dating from the Early to Late Iron Age. The ring-headed pins are more closely datable to the Late Bronze Age/Early Iron Age, around 800–600 BC.

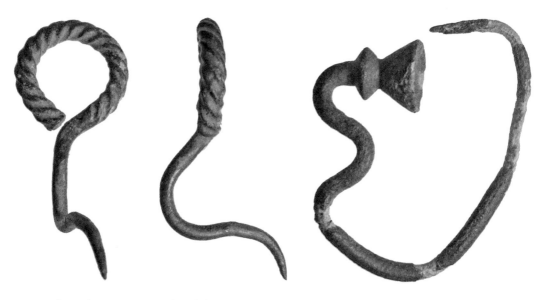

Left: Early Iron Age ring-headed pin from Lyford, 44 mm in length while the external diameter of the head is 19 mm.

Right: Another style of swan-neck pin, also of Early Iron Age date, 34.5 mm in length. This pin was donated to Oxfordshire Museums Service by the finder. (BERK-AB5D68)

Swords were not as common during the Iron Age as they were in the Bronze Age. Their restricted appearance suggests they were reserved for a select group of individuals. Sword blades were most likely of iron and are therefore not often found by metal detector users, but certain fittings on the scabbard were of copper alloy. Chapes covered the end of a scabbard to protect both the weapon within and the wearer. This unusual scabbard chape, discovered at West Hanney in 2009, is anchor-shaped, with hollow, bulbous terminals on the ends of the arms. In very good condition it can be paralleled with examples from the continent dated to the sixth century BC.

Of Middle Iron Age date, this sword scabbard from Minster Ditch, North Hinksey, shows how the Hanney chape would have fitted on to the end of the sword scabbard. The scabbard is on permanent display in the Ashmolean Museum (accession number AN1921.104).

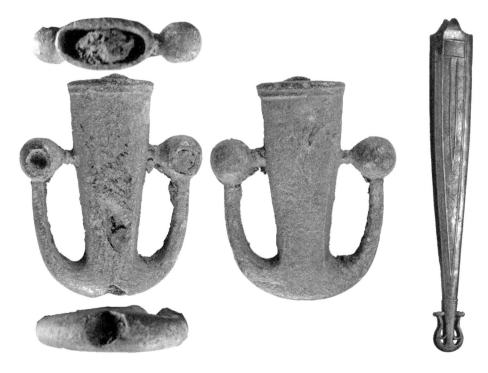

Left: Scabbard chape from West Hanney, 35 mm in length.

Right: Sword scabbard from North Hinksey. (Ashmolean Museum, University of Oxford. Reproduced with kind permission.) (AN1921.104)

Brooches appear from around the fifth century BC and could have been used for a variety of purposes including securing clothing, fastening bags or just for decoration. During the Iron Age brooches of both bronze and iron appear in an array of styles. Some brooches display additional ornamentation such as coral, which was imported from the Mediterranean. Brooch styles can be very regional; certain styles of brooch may have identified an individual as part of a certain group, as the distribution of the 'Vale' brooch of Oxfordshire and Berkshire attests.

This unusual style of brooch has only recently been recognised as a local Oxfordshire/ Berkshire type. Probably dating from around 300–150 BC, this brooch from Kingston Bagpuize is formed of four hollow, bulbous domes arranged in a square and forming a lozenge-shaped openwork centre. The uppermost two domes are marginally larger in diameter than the lower two. The domes are linked together by a short neck decorated with simple vertical lines across the width of the moulding, producing a rope-like corded collar while the domes themselves are plain and undecorated. The reverse of the brooch retains the robust catch plate and the double pin lug retains a fragment of the iron pin.

This brooch is one of an increasing number of examples (fourteen at the time of writing) seemingly concentrated around the Vale of the White Horse and West Berkshire area over the Ridgeway. There are a small number of outliers but the concentration indicates a local source. Characterised by their bulbous mouldings, they appear in a variety of shapes, including square (this example), lozengiform, cross (quatrefoil around a central dome or variant) and circular.

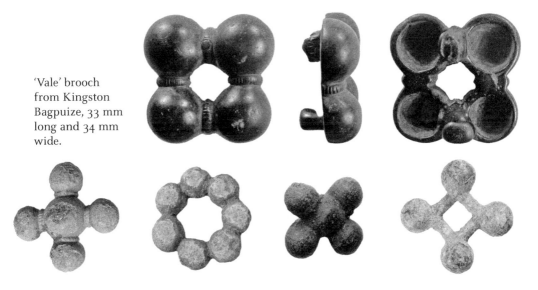

'Vale' brooch from Kingston Bagpuize, 33 mm long and 34 mm wide.

Examples of various forms of Vale brooch, from left: BERK-4451E9; BERK-5F3CA5; BERK-F5AF04; WILT-BF5093.

33

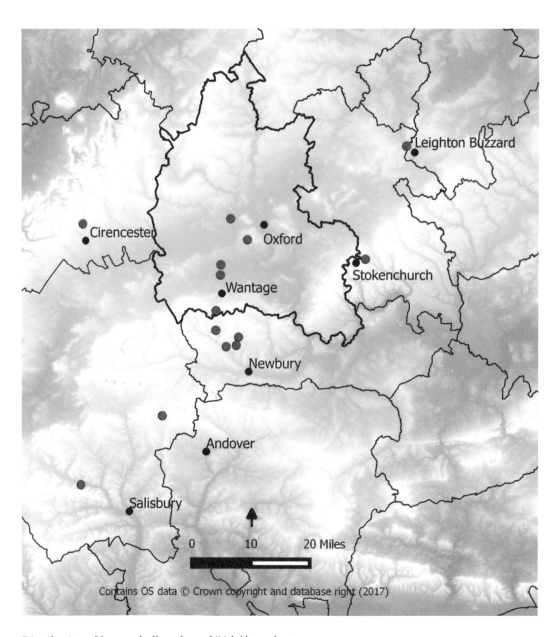

Distribution of known hollow-domed 'Vale' brooches.

A poorly understood artefact type is the so-called 'horn cap', a dumbbell-shaped object with no obvious function. A rare class of artefact, there are only about twenty or so in museums or private collections. The Kingston Bagpuize example is missing its two ends caps, which on other examples are elaborately decorated. It is made from several parts, cast separately in moulds and then put together. There is a circular void through the centre that is very narrow in the base section but widens significantly in the upper section. One side of the horn cap may display an area of wear, having a shine that is not present elsewhere on the shaft.

Several theories for the function of horn caps have been put forward. They were almost certainly not made to fit on the end of the axle of an Iron Age chariot, which was a popular suggestion when they were first discovered and studied in the nineteenth century. Horn caps have only been found in Britain, and have never been found in other parts of Europe. Made during the Middle and Late Iron Age (*c*. 300 BC to AD 43), several have been found with other Iron Age objects, thus confirming their dating, but none have been found in Iron Age chariot burials, of which around 120 are known. Several examples were found at Ham Hill in Somerset and others have been found in the River Thames. Three others have been found in Oxfordshire at Goring, Woodeaton and Stanton Harcourt.

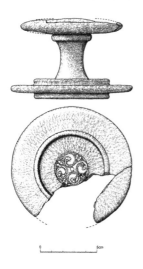

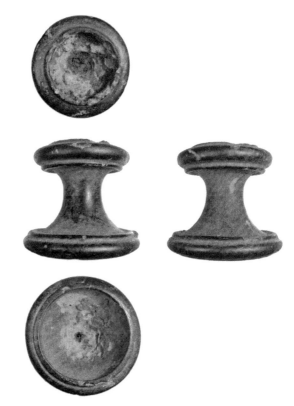

Above: Illustration of a decorated horn cap found near Braintree in Essex. (SOMDOR-699AD4) (Trustees of the British Museum/ PAS. Edited by A. Byard 2017.)

Right: Horn cap from Kingston Bagpuize, 47 mm high with a maximum diameter of 52 mm.

35

Another poorly understood artefact type is the enigmatic 'fob dangler', an object that may have been suspended from a horse harness, personal equipment or worn as a dress accessory. These intriguing artefacts often depict the *triskele* design, from the Greek word meaning 'three-legged'. The interlocked spiral motif is seen in early prehistoric rock art but is most commonly associated with Iron Age art, where it appears on many objects in various guises. The head of the Bampton fob takes the form of a moulded *triskele* motif of three equal spirals, each with a concave strand and sub-circular terminal. A circular cross-sectioned shank extends from the back of the head and terminates in a circular loop now filled with iron corrosion. Of the seven examples of fob danglers recorded by the PAS from Oxfordshire, all but one displays the triple spiral motif.

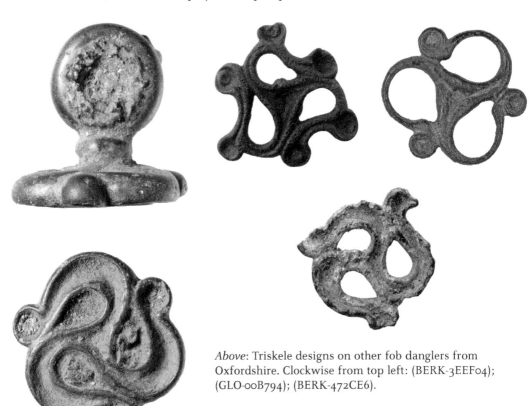

Above: Triskele designs on other fob danglers from Oxfordshire. Clockwise from top left: (BERK-3EEF04); (GLO-00B794); (BERK-472CE6).

Left: Fob dangler from Bampton, 21 mm high with a width of 21 mm.

Horses were revered during the Iron Age. Although there is some evidence that horse (and dog) skins were removed from carcasses, horses did not seem to have been eaten during the Iron Age; rather, they were used for riding or pulling small carts or chariots.

The Britons were renowned horsemen and fighters, with Julius Caesar commenting on the effectiveness of the cavalry in his narrative *The Gallic Wars:*

> In chariot fighting the Britons begin by driving all over the field hurling javelins, and generally the terror inspired by the horses and the noise of the wheels are sufficient to throw their opponents' ranks into disorder. Then, after making their way between the squadrons of their own cavalry, they jump down from the chariots and engage on foot ... By daily training and practice they attain such proficiency that even on a steep incline they are able to control the horses at full gallop, and to check and turn them in a moment. They can run along the chariot pole, stand on the yoke, and get back into the chariot as quick as lightning.
>
> (Julius Caesar, *The Gallic Wars*, Book V)

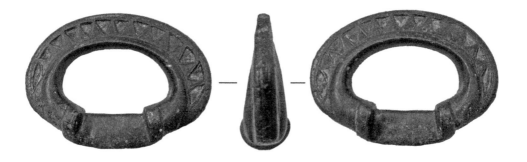

Terret ring from Great Milton, 44 mm high with a width of 62 mm.

The importance of horses is reflected in the often elaborate harness fittings found by metal detectorists. Some artefacts actually depict horses while others are inlaid with brightly coloured enamels – a technique we first see developing during the Late Iron Age. This impressive flat-ringed terret (rein guide) from Great Milton retains much of the enamelling. Terrets come in many shapes and sizes. Some are very simple without elaborate mouldings or decoration, but the Great Milton example stands out because of its size, enamelling and condition of survival. The terret ring is sub-oval (D-shaped) in plan, with an irregular sub-oval cross section. A crescent of thirteen triangular cells forms the decoration around the upper loop of the terret on either side. Much of the red enamel filling remains intact. The thin rectangular-sectioned bar at the base of the terret is flanked by two oval mouldings that expand to form the loop of the terret and this is where the terret would have been attached to the yoke of a cart or chariot.

Jonathan Waterer driving historian Mike Loades in a reconstruction of a Late Iron Age chariot. (Richard Hopkins. Reproduced with kind permission.)

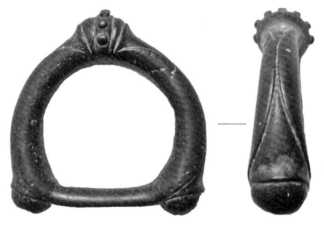

Several other terret rings have been recorded from Oxfordshire, with this elaborately moulded example from Chesterton currently unparalleled in the literature. This terret ring is 36 mm high with a width of 35 mm. (BERK- FCF8E2)

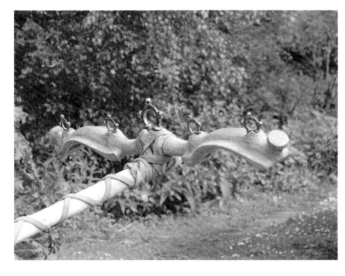

Reconstruction showing how terret rings were used. (Richard Hopkins. Reproduced with kind permission.)

This vessel mount is one of only a handful to exhibit human representations from Late Iron Age Britain, and as such is a rare and important discovery. Dating to the first century AD, the mount consists of a hollow-cast humanoid face, probably male, wearing a horned headdress. Hair appears to be represented over the brow and the facial features are depicted in plain detail. The horns of the headdress protrude outwards before curving down and round, towards the face, and are reminiscent of cattle horns. A large and thick suspension loop protrudes from the top of the head and this would have been where the handle of the vessel was secured. Interestingly, the reverse of the bucket mount retains some of the vessel. The mount is secured to the vessel by way of two copper-alloy rivets, the ends of which extend through the horns of the headdress.

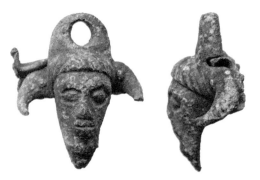

Anthropomorphic vessel mount from near Wallingford, 62 mm high with a width of 52 mm.

Human depictions are not common in Iron Age art, but the combination of a human head with cattle horns is significant. The majority of Late Iron Age bucket mounts depict bovines, and where they do appear in human form they depict the figure wearing a horned helmet or with horns protruding from the head. Bulls were seen as a symbol of power and were a common representation in Late Iron Age and first century Britain. A bovine vessel mount from Cassington, although of early Roman date, clearly shows the continuation of Iron Age cultural and religious belief.

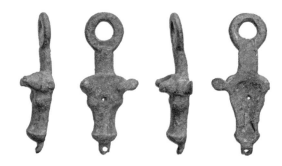

Bovine vessel mount from Cassington, 64 mm high with a width of 27 mm. (BERK-A03B79)

Coinage did not appear in Britain much before the mid-second century BC. The few coins that were present towards the end of the Middle Iron Age were imported from Gaul (parts of modern Belgium and France) and were later copied by Kentish tribes. These early coins were termed '*potins*' by numismatists because of the high tin content in the copper alloy. A good number of the Kentish imitations are known, often being called Thurrock *potins*, while the PAS has recorded a handful of the original Gaulish imports, including this example from Drayton. A rare find for Britain, the coins are known as Massalia Bull *potins*, named after their place of issue (Marseilles, France). The reverse of the coin features a bull and the letters MA for Massalia and the obverse (the 'head' side) depicts Apollo, who was frequently seen on Greek coins of Alexander the Great, and on which the early Gaulish coins were based.

The Kent-based Cantii tribe were the first to issue British coins between around 80–60 BC. Coinage soon caught on and other tribes began issuing their own, mostly in gold but with some silver and bronze issues. The designs were based on the original Greek coins, featuring the head of Apollo on the obverse and a horse on the reverse. Increasingly the designs become abstracted and regionally varied. Coinage would have been restricted to the elites, and were possibly used to pay tribute or taxes to other tribes and rulers. For the majority of people, bartering would still have been the main means to buy and sell goods.

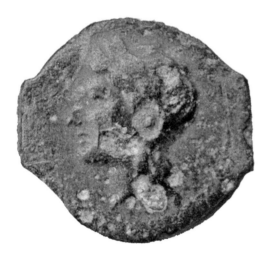 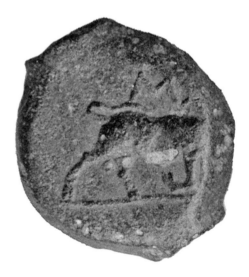

Massalia Bull *potin* from Drayton, 18 mm in diameter.

The earliest gold and silver coins, known as staters and units, are uninscribed, meaning that there is no name on the coin to attribute it to a specific ruler. For the early coins we rely on regional variation to distinguish the tribe and place of issue. All three Iron Age tribes that inhabited parts of Oxfordshire issued their own coinage. As contact with the Romanised world intensified during the early first century AD, coins tended to become more recognisable to modern eyes, with a head and name of the ruler on the obverse and a tribal motif or meaningful design on the reverse.

Five uninscribed gold staters of the so-called 'Chute' or 'British B' type, produced in around 80–60 BC, were found close together at Milton-under-Wychwood in 2013. All of the coins feature an abstract pattern derived from the head of Apollo on the obverse and a stylised left-facing horse with pellets above on the reverse. Coins of this type are most commonly found in the Hampshire–Dorset area, so being found at Milton-under-Wychwood is interesting as they are beyond their usual area of circulation.

Because more than two gold coins over 300 years old were found in close association, they qualify as Treasure under the 1996 Act. After the finder and landowner were reward, Oxfordshire Museums Service was able to acquire the hoard.

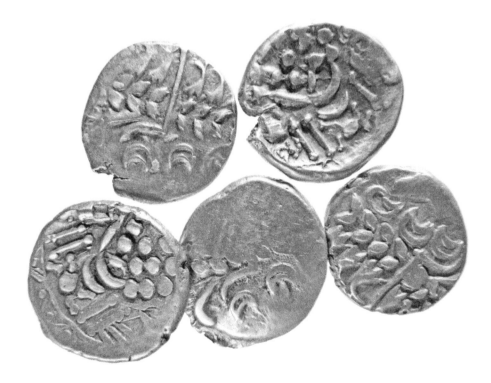

'Chute' gold *stater* hoard from Milton-under-Wychwood with an 18.5 mm average diameter.

20. Abingdon Zoo silver unit from Nuffield (SUR-00035D)
Late Iron Age (*c.* 55–40 BC)

Of a type unknown until 1995, this coin appears to be restricted to South Oxfordshire and north Berkshire. Named the 'Abingdon Zoo' type after the proximity of the first find to the town, the coins depict a menagerie not previously seen on British coins. The type is extremely similar to rare issues by the Ambiani tribe of Belgic Gaul, but rather than having had direct contact with Belgic Gaul it is probable that the manufacturers of the Abingdon Zoo coin copied the Ambianic type, adding their own designs. The Abingdon Zoo coins are extremely rare; only around twenty are known and unfortunately many of the early discoveries have no provenance. Two coins recorded with the PAS are provenanced – an important factor when trying to identify and determine new types of coin and artefact. The Nuffield example depicts paired animals, including wild boar and stylised horses with beaded manes and upcurving tails, surrounded by other animals.

Iron Age coin experts Chris Rudd and Philip de Jersey suggest the existence of a small tribe, now nameless, who were striking coins between 55–40 BC in Berkshire and South Oxfordshire, between the rivers Ock and Kennet, possibly centred at or near Dorchester-on-Thames. It is hoped that as more of these coins are recorded with good provenance it will be possible to identify the location of manufacture, and possibly even the identity of the people who were striking them.

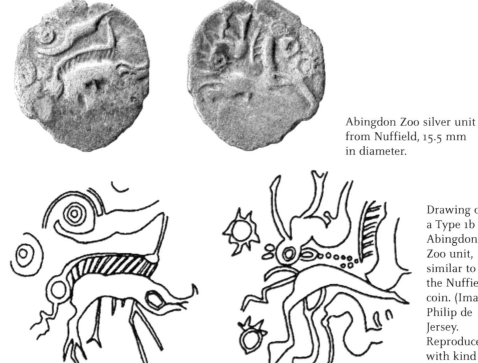

Abingdon Zoo silver unit from Nuffield, 15.5 mm in diameter.

Drawing of a Type 1b Abingdon Zoo unit, similar to the Nuffield coin. (Image Philip de Jersey. Reproduced with kind permission.)

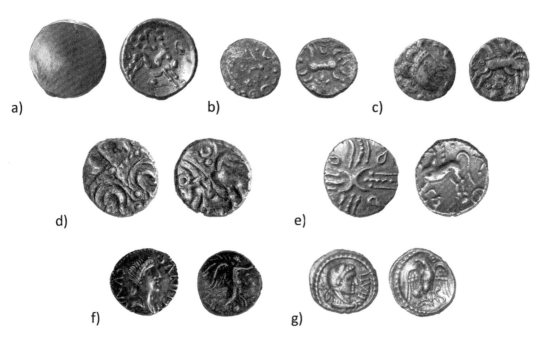

Examples of gold and silver Late Iron Age coins from Oxfordshire:
 a) Continental (Belgic) gold *stater* from Shiplake, *c.* 60–50 BC. (SUR-E3D258)
 b) Silver unit of the Dobunni from Stanton Harcourt, *c.* 50–20 BC. (BERK-5910D8)
 c) Silver unit of the Dobunni from Burford, *c.* 50–25 BC. (SWYOR-597E71)
 d) Gold *stater* of Tasciovanos of the Catuvellauni / Trinovantes from Culham, *c.* 25 BC–AD 10.
 (BERK-B5B877)
 e) Gold *stater* of the East Wiltshire (Vale of Pewsey) group from Letcombe Bassett, 50–35 BC.
 (BERK-E5DFF3)
 f) Silver unit of Cunobelin of the Trinovantes from Lewknor, dating to *c.* AD 10–40.
 (BERK-85E093)
 g) Silver unit of Epaticcus of the Atrebates from Stanford-in-the-Vale, *c.* AD 20–40. (SUR-D114F8)

43

Chapter 5
The Roman Period (AD 43–409)

Although Julius Caesar made two incursions to Britain in the first century BC, it was not until nearly a century later that Claudius successfully invaded. Archaeological research has shown that far from the invasion being a huge upheaval for this island's inhabitants, life continued much the same as it always had. There would have been exceptions certainly, especially for some tribal chiefs who suddenly found themselves inferior to a foreign power, but for most daily life continued more or less the same. One of the biggest changes would have been the influx of people, who brought with them new goods and exotic gods.

Oxfordshire has many Roman period sites, from small farmsteads to large villas, military encampments and temple sites. The county is crossed by major Roman roads, including Akeman Street in the north of the county and another that ran north–south, linking Silchester in Hampshire to Dorchester-on-Thames and Alchester near Bicester. Many smaller roads are known across the county.

Cross section through Akeman Street, near Tackley. The constituents of the road construction and the surface paving can be clearly seen. (John Perkins. Reproduced with kind permission.)

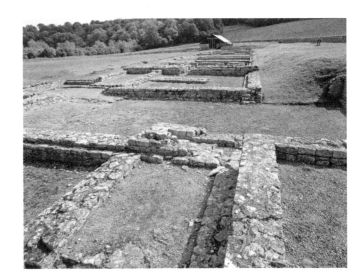

North Leigh Roman villa, which was one of the biggest in England by the fourth century AD. (A. Byard. Reproduced with kind permission of English Heritage.)

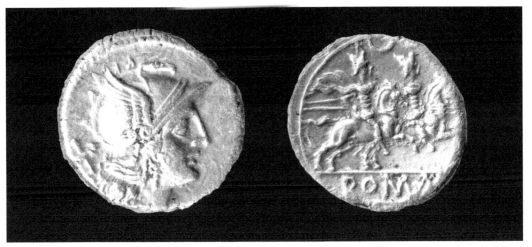

This Roman republican *denarius* from West Ilsley, Berkshire, is 18.5 mm in diameter. (BERK-65D307)

The range of non-ferrous objects made in and imported to Britain during the Roman period is extensive; in copper alloys there are coins, brooches, finger rings, furniture fittings, cart fittings, personal hygiene and medical implements, religious and iconographic statues and figurines, belt buckles, spoons and pans. As well as being used in coinage, the more precious metals of silver and gold were used to produce more expensive items of personal adornment.

Coins make up the largest proportion of Roman period finds recorded by the PAS from Oxfordshire; around 12,200 individual coins at the time of writing. Although Republican silver denarii are not particularly rare, they are often found associated with much later coins as they were still in circulation due to their bullion value. The earliest single find of a Roman silver coin featuring the head of Roma and the galloping Dioscuri and dated to around 211-207 BC, came from the Berkshire–Oxfordshire border near the Ridgeway.

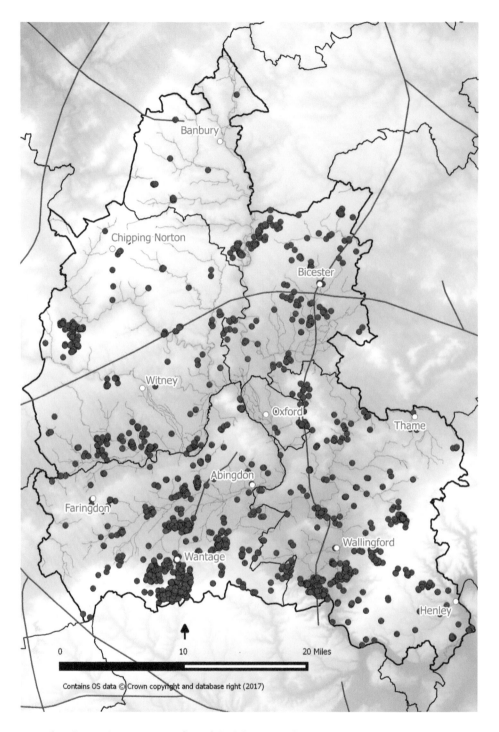

Map showing main Roman roads and PAS Roman coins.

21. Figurine of Mercury from Beckley (BERK-F1499B)
Roman (AD 43–199)

Roman religious beliefs mingled with those of the native population and those of non-Roman citizens who came with the army. Religious beliefs are evidenced by an array of 'small finds' as well as larger deposits of coin and metalwork hoards. This incomplete figurine of Mercury wearing a silver torc was found near Beckley in 2014. The figurine is in very good condition, with the facial and body features clearly depicted. Mercury is the messenger of Jupiter and the patron god of travellers and merchants. Holding a purse in the palm of his right hand, Mercury is naked apart from a short cloak (a *chlamys*) draped over his left shoulder. In the missing left hand he probably held a *caduceus*, a winged staff carried by messengers and heralds. Mercury's most famous symbols – the wings on his head and feet – are missing due to old breaks. The silver torc has flattened and pointed terminals decorated with incised lines, possibly intended to depict a serpent, which was another of Mercury's symbols.

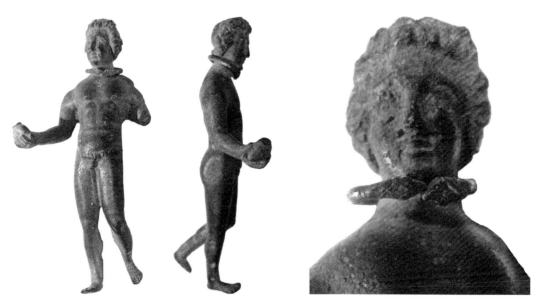

Left: Figurine of Mercury from Beckley, 78 mm tall.

Right: Close up of silver torc on the figurine of Mercury from Beckley.

A small number of non-coin finds from Oxfordshire depict Roman gods and goddesses. A mount from Woodstock depicts the Greek god Pan, who later became the Roman god Faunus. Primarily a rural deity, Faunus was the god of fields, forests and plains.

Depictions of gods don't just appear as figurines but also as vessel mounts and knife and spatula terminals. A small number of sceptre terminals depicting gods are known, including this sceptre head from Bix that may depict the emperor Antoninus Pius (AD 138–161), possibly as part of the emperor-worshipping practice known as the Imperial Cult. In this dead, or even living emperors and their families were considered deities and were worshipped accordingly, especially in provinces such as Britain.

Mount of Faunus from Woodstock, 26 mm tall. (BERK-44D627)

Sceptre terminal depicting Antoninus Pius from Bix, 44 mm tall. (BERK-BF8EC4)

After coins, Roman brooches are the second most common artefact type recorded by the PAS. Coming in a variety of styles, some have regional distributions, some may have religious connotations, and some are purely functional. Brooches can appear in anthropomorphic, zoomorphic and even skeuomorphic types. Cockerel, horse-and-rider and even axe and shoe brooches have all been recorded from Oxfordshire. There is some discussion as to whether brooches of these types were associated with specific deities; for example, the horse and rider brooches may be associated with the horse goddess Epona, and the cockerel, fly and shoe brooches with the cult of Mercury.

This brooch from Crowmarsh depicts a running stag. In Iron Age religion the stag was the embodiment of the horned god Cernunnos, Lord of the Wildwood. In Roman religion it is Silvanus, or Faunus, the god of woods and forests. The craftsmanship of the brooch suggests that it was made on the continent. The long head of the stag is well-modelled, with an open mount and the large oval eye. An ear projects below the antlers, which are joined together to form a loop, possibly for a chain to connect to an opposing and matching brooch. There are two enamelled panels within the body of the brooch but no enamel survives; a circular setting above the forelegs may have held a decorative bead or insert. Although the lower legs are missing and the pin is missing from the back, the brooch has survived in very good condition. Only a handful of these brooches have been recorded in Britain, this being one of the best examples from the PAS.

Stag brooch from Crowmarsh, 29.8 mm in length.

Although there is a wealth of surviving Roman material culture, away from burial contexts it is extremely unusual to be able to identify the owner of an object, much less name them. This thin rectangular sheet of gold (*lamella*) was found rolled up, but under expert guidance at the British Museum the sheet was unrolled to reveal an internal inscription. Of second or third century date, the cursive script is Greek and contains magical symbols and thirteen lines of text. The inscription appears to be a prayer from a grandmother asking for the safe delivery of her grandchild:

Gold *lamella* from Cholsey, 63.1 mm long with a width of 28.3 mm.

Make with your holy names that Fabia whom Terentia her mother bore, being in full fitness and health, shall master the unborn child and bring it forth; the name of the Lord and Great God being everlasting.

Only the third of its type when discovered, this important artefact is a poignant reminder of the dangers of childbirth, and the faith in which the gods were held. It is also an indication of the diversity of Roman Britain. Whether it was inscribed in Britain or imported by the woman Terentia is uncertain.

24. The Chalgrove Hoard (PAS-879F02)
Roman (*c.* AD 279)

Discovered by a detectorist in 2003, the Chalgrove Hoard contained 4,957 Roman coins dating from between AD 251 and 279. The hoard was found only 100 metres from another hoard of a similar size that the same detectorist had found in 1989. What makes the Chalgrove hoard so important is the discovery of a single coin of Domitianus, a previously unrecognised emperor of the Gallic Empire. During the third century the Roman Empire was in strife, with political splits resulting in emperors being usurped in quick succession across the empire. Only one other coin of Domitianus is known, discovered in France a century ago. At the time scholars thought it was a fake as no other archaeological evidence for the emperor was known. The brief references found in ancient texts were thought unreliable, but the Chalgrove coin proves that he did exist. A high-ranking military officer and usurper, Domitianus may have ruled for only a few days before disappearing from history around AD 271.

Coin hoards of the late third century AD are not uncommon, with well over 600 known. The reason so many coin hoards were buried at this time was thought to be due to the instability of the Roman Empire and the threat of barbarian raids from across the Channel. However, the archaeological evidence from much of England shows a period of increasing prosperity, not destruction, so the majority of these hoards may have been buried for economic rather than political reasons.

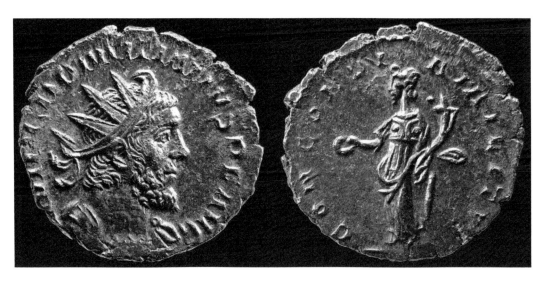

Coin of Domitianus from the Chalgrove Hoard. (Trustees of the British Museum/PAS.)

The majority of Britons would have been pagan until well into the late seventh or eighth century AD, even though Roman emperor Constantine the Great is said to have converted to Christianity in AD 312. Constantine had ended religious persecution of Christians by Pagans and introduced religious tolerance.

This cosmetic implement from Mixbury, known as a nail-cleaner strap-end, is dated to the late fourth century AD. On its upper surface is a depiction of a peacock facing a stylised horse, surrounded by a border of punched crescents. The peacock was associated with immortality and the Resurrection and was depicted in mosaics and wall paintings, as well as on sarcophagi and in church windows. The connotation of the design would have been clear to the object's owner. Christian iconography seen on other nail-cleaner strap-ends include the chi-rho symbol, a griffin, and a fish.

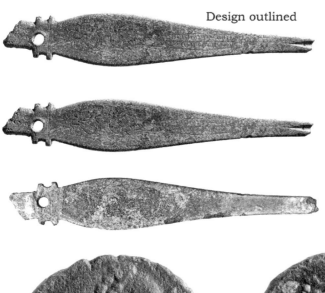

Design outlined

Left: Nail-cleaner strap-end from Mixbury, 71 mm in length.

Below: Coin of Constantius II from Milton-under-Wychwood depicting the chi-rho Christogram flanked by alpha and omega on the reverse. Dating from AD 352–53 it was made in the mint of Trier, Germany, and is 23 mm in diameter. (BH-59FB5C)

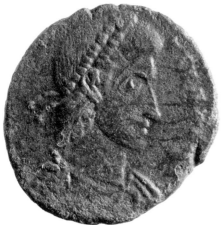
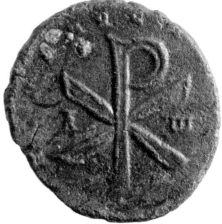

Roman locks are rare objects and this example from Bix and Assendon survives in remarkable condition. The padlock case is in the form of a female head, with parted hair clearly visible. There is a circular hole on the left side of the head while on the right side is the key hole. On the apex is a rectangular collar with an aperture. Below the head is a semi-circular projection with a possible broken hinge. There are iron traces on the back but the entire locking mechanism is now missing. The case may be a representation of Minerva, the goddess of commerce, industry, wisdom and the crafts, but few of these objects are recorded and there is yet to be an in-depth study into them. Only three other padlock cases have been recorded by the PAS (YORYM-89CD53, LIN-3BC5E5 and DOR-695A14).

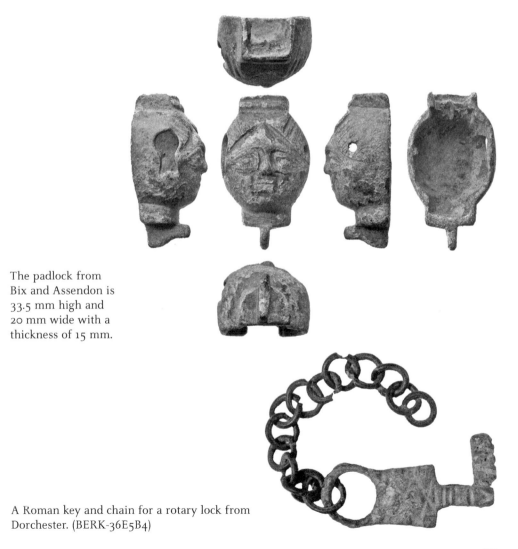

The padlock from Bix and Assendon is 33.5 mm high and 20 mm wide with a thickness of 15 mm.

A Roman key and chain for a rotary lock from Dorchester. (BERK-36E5B4)

This rare object is a seal matrix, with the name 'Nemnistius' cast in retrograde. The matrix may have been used for impressing a name into a soft substance, such as butter or clay; the Oxford region made large quantities of pottery during the second and third centuries AD, and some vessels are stamped with the name or mark of the potter, but as yet there is no parallel for this rare object. The matrix is roughly rectangular and has been very crudely cast. On the back of the matrix is the stub of an iron handle, now broken. The lettering on the face of the matrix is formed of vertical and diagonal strokes, indistinctly divided, making it difficult to distinguish between 'M', 'N' and 'V'. The 'S's are distinct, with the termination 'ISTIVS' clear enough, but the preceding two to three letters could be read as 'MIV', 'NN' (ligatured) 'V', or 'NVV'. With this in mind, the most likely reading of the name is 'NIIMNISTIVS' (Nemnistius).

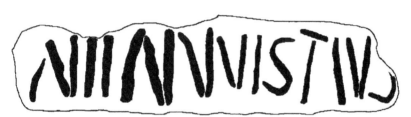

Detail of the lettering on the Culham seal matrix, probably reading 'NIIMNISTIVS'.

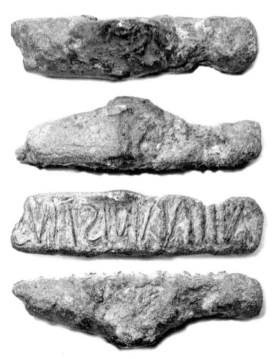

Seal matrix from Culham, 61.5 mm in length.

Gold Roman coins are not common finds. Single gold (or silver) coins are not classed as Treasure under the 1996 Treasure Act, and once recorded they are returned to the finder. The lack of recorded examples is probably due to their rarity rather than the unwillingness of detectorists to record. This gold coin, called a *solidus* and dating from around AD 388–392, depicts general Theodosius I, emperor of the Eastern Empire. On the reverse he is seen seated with Valentinian II, emperor of the Western Empire. Theodosius was the last emperor to then rule over both the Eastern and Western Roman empires. He died in Milan in AD 395. There are only three other examples of Theodosian *solidi* recorded on the PAS database.

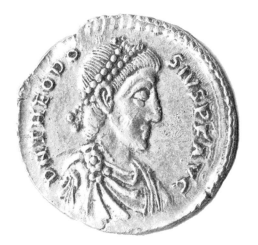 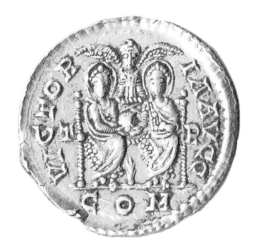

Solidus of Theodosius I from Kingston Bagpuize with Southmoor, 21 mm in diameter.

Roman dividers are uncommon objects and of those known, the vast majority are plain, undecorated utilitarian objects. This pair of complete cast copper-alloy dividers is highly decorated and is of late Roman or early Saxon date. The dividers take the form of two long, straight arms that taper to a point, which are now corroded in the closed position. The arms are held at the top by an iron spindle, forming a hinge. The ends of the spindle have added copper-alloy mounts, one in the form of an eagle's head and the other a rounded bulb. The eagle's head is attached to a rod, through which is a slot with the remains of an iron peg; when the arms were opened to the desired width, the peg could be pushed down to lock the arms in place. The arms are elaborately decorated with running ring-and-dot motifs, with several retaining red enamel. These are surrounded by a continual border of crescents and below are more ring-and-dot motifs.

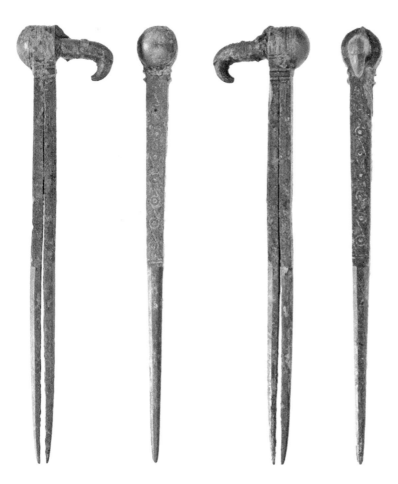

Dividers from Lyford, 175 mm in length.

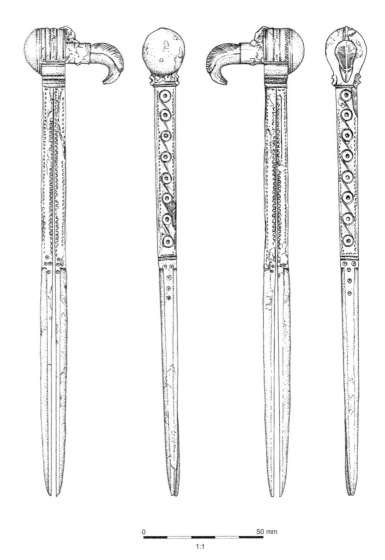

Illustration of the Lyford dividers. (Magdalena Wachnik, Oxfordshire Museum Service/Portable Antiquities Scheme.)

0 50 mm

1:1

A similarly decorated pair from Shouldham, Norfolk, are considered to be of first or second century AD date but although they are very similar in the enamelling and the eagle or bird's head, the use of running ring-and-dot motifs does suggest a late Roman or even early Saxon date (*c.* 350–600 AD; Martin Henig (Oxford University) and Paul Booth (Oxford Archaeology), pers. comm.). The crescentic lugs at the top of the arms are paralleled in late Roman nail-cleaner strap-ends (*see find 25*), and the crescentic decoration is also seen on late Roman/early Saxon buckles (*see find 30*).

In Christian iconography the eagle is symbolic of the Resurrection and St John. It is generally assumed that dividers were used for surveying, but they would have been useful for designing objects such as hanging bowls and for illustrating illuminated manuscripts (Martin Henig, pers. comm.). Whatever their original function, these dividers are of the highest quality and would have belonged to someone of considerable wealth and status. The finder kindly donated these amazing dividers to the Oxfordshire Museum Service.

Chapter 6
The Early Medieval Period (AD 409–1066)

The period between the withdrawal of Roman administration in Britain and the Norman Conquest of AD 1066 is called the Early Medieval period. This period sees the widespread introduction and adoption of Christianity and the rise of large, powerful kingdoms such as Mercia and Wessex. In sixth and seventh-century Oxfordshire, the dominant political group were the Gewisse (West Saxons), whose tribal centre was around Dorchester-on-Thames. Groups of large buildings called hall complexes have been found at Sutton Courtenay and Long Wittenham and are thought to be the royal palaces of the Saxon kings. In the early Saxon cathedral at Dorchester, Saint Birinus converted the Gewisse king Cynegils to Christianity in AD 636.

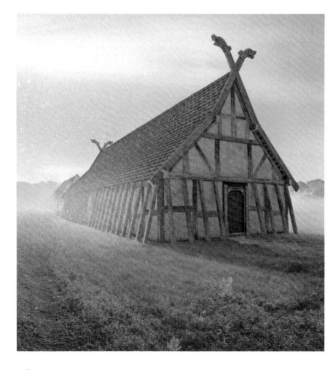

Artist's impression of the Saxon Great Hall at Sutton Courtenay. (Oxfordshire Museum Service. Reproduced with kind permission.)

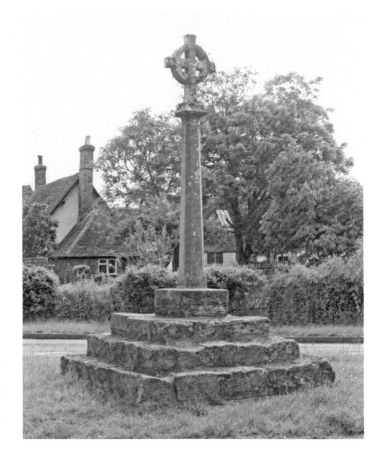

Long Wittenham village cross, where St Birinus is said to have preached to the heathen locals in the seventh century AD. (Paul Otter.)

Much of our information on Saxon culture comes from cemeteries, with large-scale burial sites known across the county. The Dyke Hills at Dorchester, although of Iron Age construction, were reused in the early fifth century for the burial of Saxon immigrants. These late Roman or early Saxon graves provided a wealth of material culture in styles not previously seen in England.

At the very end of the Roman period, a new and distinctive type of buckle is seen, first recorded from burials in the Dyke Hills at Dorchester. These feature heavily stylised dolphins, sometimes with horses' heads projecting from the frame. This amazing example from South Leigh is one of the best preserved examples away from an archaeological context. The buckle has a pair of facing dolphins with open jaws on the outer loop. Each dolphin has a horse head extending from its crest. The plate is decorated with multiple crescentic and S-shaped motifs within a border of pellets. The rivets would have secured the buckle plate to a leather strap that would have been inserted between the copper-alloy sheets. The buckles are associated with foreign settlers of the late fourth and early fifth century and it has been suggested that the settlers were Germanic mercenaries who came to Britain after the official withdrawal of the Roman administration in AD 409.

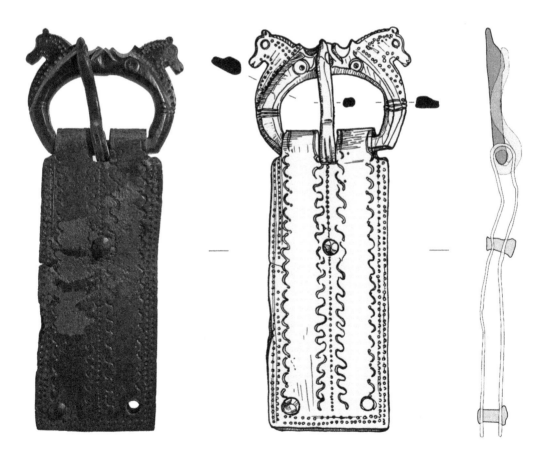

Late Roman buckle from South Leigh, 79.5 mm in length with a width of 23 mm.

This very unusual pin is probably of western Frankish (Germanic) origin. The elongated, sub-trapezoidal head of the pin is decorated with two fantastical animals, both with their heads turned to bite their own tails. The rear animal has a large, crescentic feature over its head, akin to a bow, while the other animal's head is flanked by two blocky L-shaped motifs. A border of simple punched dots and triangular ornaments complete the design, with gilding remaining in nearly all of the decorative elements. Objects of Frankish origin or influence often depict animals that are often heavily stylised and become more devolved as the period and regional art styles develop. There is no close parallel for this wonderful object, however a similar styled pin is in Rouen Museum.

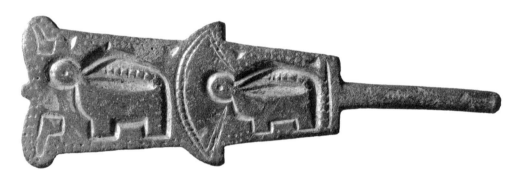

Above:
Sixth-century pin
from Somerton,
94 mm in length.

Right: A
distinctive
Frankish S-shaped
bird brooch,
AD 475–575.
(KENT-D90FBC)

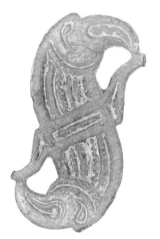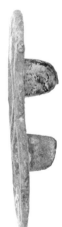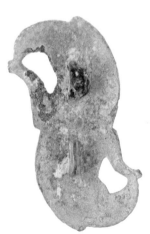

Dating from the middle to late sixth century AD, burial evidence has shown that these large brooches were worn on the shoulder, predominantly by men. This brooch features abstract zoomorphic designs of heavily stylised animals and anthropomorphic face masks around the head of the brooch. Beneath the bow of the brooch, on the left and right, projections and a large raised mask adorns the foot of the brooch. Gilding would have covered the front of the brooch and some traces can still be seen.

Many other brooches of this period have been recorded by the PAS; however, near-complete great square-headed brooches remain relatively uncommon away from burial contexts. Saucer and button brooches – so called because of their resemblance to their namesakes – were particularly popular in the Upper Thames Valley region during the fifth and sixth centuries, and were probably manufactured in the area. Saucer brooches are associated with females and may have played a role in symbolising status and local affiliation. The running spiral design is associated with the Thames Valley, with several examples coming from cemeteries in Abingdon, Fairford and Berinsfield. Button brooches are distinguished by their small size and anthropomorphic face-mask decoration.

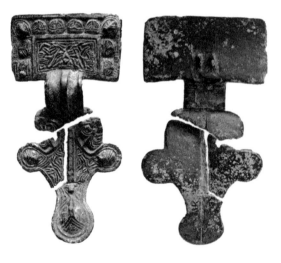

Left: Great square-headed brooch from Bicester, 149 mm in length.

Below left: A gilded button brooch from Stadhampton, 16 mm in diameter. It is thought that these brooches may have been used singly rather than in pairs like the larger brooches. (BERK-A89520)

Below right: Detail of a gilded running spiral saucer brooch, 27 mm in diameter. Oxfordshire Museum Service (accession number 1990.21.11).

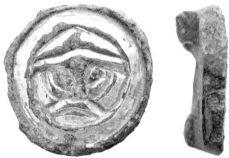

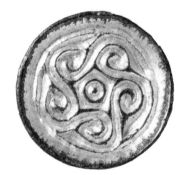

The function of these pyramidal mounts is still uncertain, but they may have been used to help secure a sword in its scabbard. This example is made from silver, inlaid with niello (a black metallic alloy) and then gilded. The top has an empty square recess that originally held a decorative setting. The sides of the pyramid mount have two designs on opposing sides; one pair has one inverted and two standing triangles, while the other sides are decorated with a stylised animal in profile, looking right. The animals are very cleverly and simply designed, with a curved body, a single leg, and the head and jaw being embellished with niello outline. An integral silver bar runs across the centre of the hollowed reverse, presumably for attachment.

Pyramidal mounts of this type were introduced in the early seventh century and continued in use for the rest of the century. Two examples were found in the high-status graves of Sutton Hoo but they are relatively uncommon as grave finds; most of the examples known are accidental losses, with ninety on the PAS database to date (six in gold, thirty-four in silver, fourty-nine in copper alloy and one in lead alloy). The silver and copper alloy versions are often inlaid with niello. This example is not quite like any other as the animal design is not paralleled.

Declared Treasure in 2014, the scabbard mount was acquired by Oxfordshire Museums Service.

Above left: Pyramid scabbard mount from Stanton St John, 14.3 mm in length with a height of 7.1 mm.

Above right: A copper-alloy pyramid scabbard mount from Crowmarsh, 8 mm high with a width of 15 mm. (BH-B72FCB)

Brooches could be status symbols as well as functional items of dress. One of the best examples of this is the Hanney Brooch, a very rare disc brooch dating to the seventh century AD. Discovered during a metal detecting rally in 2009, the finder removed the brooch from the ground only to see part of a jaw bone beneath. In accordance with best practice, the finder stopped digging and contacted the rally organisers and FLO, who arranged excavation of the burial after the police had visited the site.

The excavation revealed the skeleton of a female, around twenty-five years of age, lying with her head to the south and accompanied by grave goods. Between the woman's legs was a chalk spindle whorl and two fragments of glass, all of which were probably once contained in a cloth or leather bag. Two handmade pots and two iron tools were found on the outside of the right leg. The jumble of ribs and a missing part of the skull show where a plough blade had impacted, narrowly missing the brooch that was placed on the left shoulder. The brooch was only the twentieth of its type known when discovered.

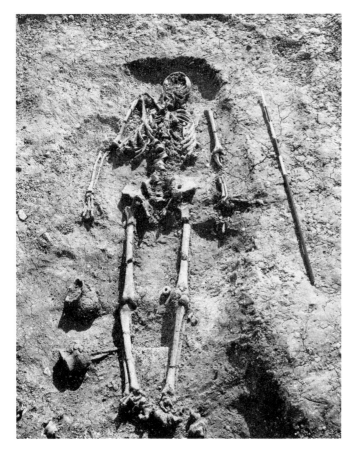

The Hanney burial after excavation. (A. Byard.)

Belonging to the Conversion Period (conversion to Christianity), the disc brooch is based on Frankish designs and is of a type more usually found in Kent. Of exceptional workmanship, the Hanney Brooch features appliques of sheet gold panels decorated with gold wire filigree arranged around a central boss of coral, secured with silver wire. Four other coral bosses complete the symmetrical, cruciform design. The garnet inlays overlie a fine gold wire mesh contained within cells (cloisons) of copper alloy.

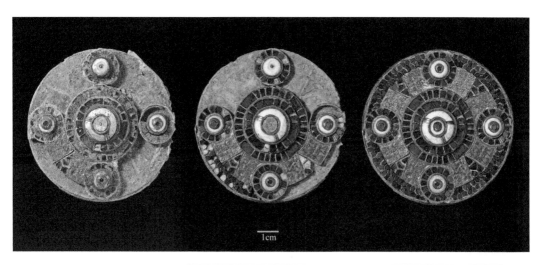

Above: The Hanney Brooch. Left to right: as found; after cleaning and conservation; digital reconstruction. (Ian Cartwright, University of Oxford, Oxfordshire Museum Service. Reproduced with kind permission.)

Right: Detail of the Hanney Brooch. (Ian Cartwright, University of Oxford, Oxfordshire Museum Service. Reproduced with kind permission.)

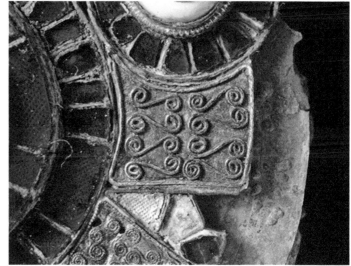

Analysis of the brooch shows there was at least one, if not two repairs. This suggests that the brooch was already old when it went into the ground. Two similar brooches were discovered at Abingdon and Milton during the nineteenth century. The similarities between the Oxfordshire brooches and those found in Kent suggests contact between the two, and possibly a shared identity, although the Oxfordshire brooches may have been made locally. (Helena Hamerow, University of Oxford, pers. comm.) The remainder of the grave goods are commonly found with female burials of the seventh century; it is the brooch that sets the grave and individual apart. It is likely that the woman was part of the ruling elite (the Gewisse), although why she was buried where she was remains a mystery.

As the brooch contained less than 10 per cent precious metal by weight it did not constitute Treasure, however Oxfordshire Museums Service purchased the brooch and other artefacts from the detectorist and it is now on display at the Oxfordshire Museum in Woodstock.

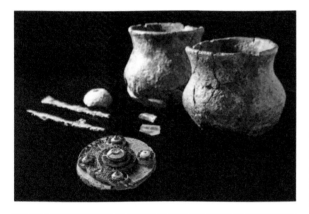

The Hanney Brooch and grave goods. (Ian Cartwright, University of Oxford, Oxfordshire Museum Service. Reproduced with kind permission.)

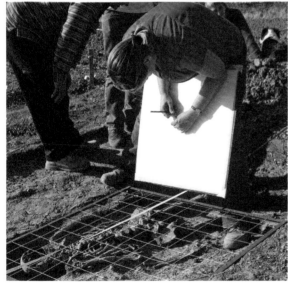

The author recording the Hanney skeleton after excavation. (A. Byard.)

Money generally disappears from the archaeological record during the six and seventh century, but by the eighth century new silver coinage began to circulate. By the ninth century coinage becomes more common and the amalgamation of small kingdoms into four super kingdoms (Northumbria, East Anglia, Mercia and Wessex) see several rulers issuing coins concurrently.

This silver penny of Cuthred of Kent (AD 798–807) was struck in Canterbury by the moneyer Sigeberht. In a practice more common during the eleventh century (from the reign of Edward the Confessor), one side of the coin has been gilded with the other left silver, so this coin is a particularly early example of the practice. It is usually the reverse of a coin that is gilded, not the obverse side showing the head of the ruler. Why this should be is uncertain, but the presence of a cross on the reverse of coins suggests a religious connotation rather than a political affiliation. However, with no sign of a mount to turn the coin in to a brooch or pendant, it is unclear why this example was gilded – it is possibly unfinished. A coin brooch from Wantage has silver mounts and was made on a coin issued by Aethelstan (AD 924/25–939).

All recent finds have passed through the Treasure process and many have been deemed to be Treasure under the terms of the Treasure Act (1996), as although a single coin does not constitute Treasure, a single item of jewellery does, and such finds are regarded as jewellery rather than as coins. The Ipsden coin did not qualify as Treasure due to the lack of evidence for change of use and it was returned to the finder.

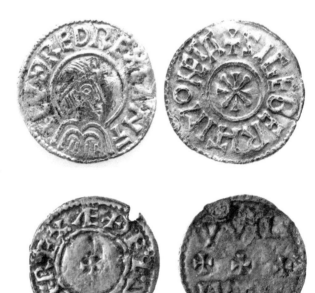

Gilded penny of King Cuthred from Ipsden, 18.9 mm in diameter.

Gilded coin brooch of Aethelstan from Wantage, 22.3 mm in diameter. (BERK-39FCC8)

On his sixtieth birthday in October 2015, detectorist James Mather was searching land near Watlington when he found a silver ingot. Recognising the find as potentially Viking, Mr Mather detected a little more and discovered a collection of coins seemingly contained in a single deposit. Following the Code of Practice for Responsible Metal Detecting, Mr Mather contacted his FLO, David Williams (Surrey and East Berkshire). After realising the importance of the discovery, the collection of artefacts, which by now contained several ingots, numerous silver coins and silver bracelets, was lifted in a block and transported to the British Museum for excavation in the laboratory.

The hoard contained seven items of jewellery, fifteen silver ingots and 186 complete silver coins, mostly of Alfred the Great (AD 849–899) and Ceolwulf II (who ruled AD 874–879). The hoard was probably deposited by a Viking for safe-keeping in the late 870s, at the time when Wessex and Mercia were fighting against the growing threat of losing their kingdoms to the Danes and the 'Great Heathen Army'. At this time Oxfordshire was on the borders of both Wessex and Mercia and the Viking forces were moving to secure control of southern England after successfully conquering Northumbria and East Anglia.

Left: Finder James Mather after the block-lifting of the Watlington Hoard. (David Williams. Reproduced with kind permission.)

Below: Coins from the Watlington Hoard. Left to right: Penny of Alfred; Two Emperors penny; penny of Ceolwulf II. (Ashmolean Museum, University of Oxford. Reproduced with kind permission.)

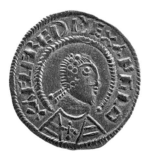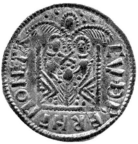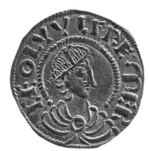

The significance of the hoard comes not only from its location, proving that the Viking forces were in Oxfordshire in the late ninth century, but also from the coins. Coins of this period are very rare, and the hoard quadruples the known number of some issues. The coins include single issues of both Alfred and Ceolwulf II – a little-known ruler and supposed puppet king of the Vikings – but most importantly there are coins known as 'Two Emperors' type, depicting both Alfred and Ceolwulf on the same coin. This has led scholars to suggest that there was a period of co-operation between the kingdoms, wherein they united against a common enemy. Ceolwulf is portrayed in contemporary texts as a 'foolish king's *thegn*' – a puppet king at the Vikings' bidding – and is all but condemned in history as a traitor to his people and kingdom. The Two Emperors coins suggest that, for a while at least, the two kings were united and minted coins in greater numbers than was once thought.

The design is based on late Roman coins, with the kings sitting on a throne underneath Victory. The hoard was buried at the end of Ceolwulf's reign and at the end of the kingdom of Mercia. Mercia was subsumed into Wessex and Alfred successfully repelled the Viking invaders, becoming a powerful and respected leader. These acts laid the foundations for the emergence of the Kingdom of England.

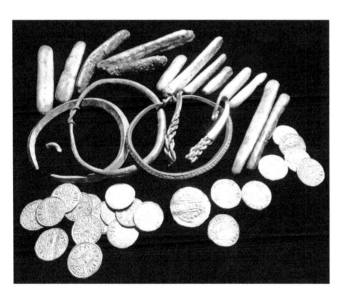

Above: Selection of coins and artefacts from the Watlington Hoard. (Trustees of the British Museum/PAS.)

Right: Statue of Alfred the Great in Wantage. (Paul Otter.)

Copper-alloy strap-ends of the ninth to eleventh centuries are common metal detecting finds. They were used to weigh down the end of a leather strap or belt, having a characteristic split end into which a leather strap was inserted and secured by rivets. Most often they have geometric and zoomorphic designs and are sometimes inlaid with niello. Higher-status examples are occasionally found and several silver strap-ends have been found in Oxfordshire.

This incomplete strap-end from Nuffield is notable in being only the second known to contain an inscribed text. Dating to the first half of the eleventh century, the silver strap-end is partially gilded and inlaid with niello. Decorated on both sides, the front design comprises a pair of sinuous beasts in profile, flanking a central foliate stem with branching tendrils. The beasts are arranged with their backs to the stem, their bodies forming an undulating S-shape. Each beast has one visible eye, represented by a tiny dot, and one visible leg extending from the base of their bellies, terminating in a foot that rests against the object's edge. The opposing side of the strap-end features a now-incomplete *Agnus Dei* (Lamb of God) motif, surrounded by an incomplete inscription in Old English text:

[-] Ð M E C A H. ('-đ mec ah', translated as '-đ owns me'.)

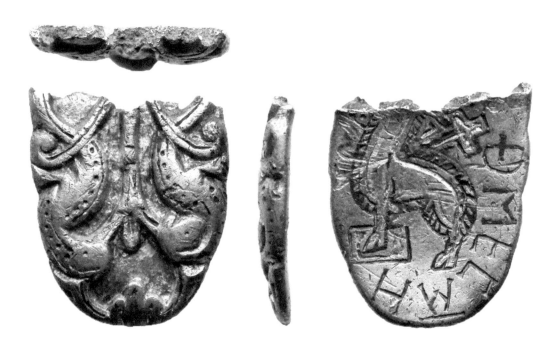

Inscribed Anglo-Saxon strap-end from Nuffield, 19.7 mm long and 16.5 mm wide.

Many Old English names, both male and female, end in -ð, so unfortunately we can't guess at the name nor even at the sex of the owner, but we know that they would have been someone with considerable wealth. The only other example of an inscribed strap-end of this date is from Somerset, the inscription reading: 'W[V]LFSTAN M[E]C AH A', or 'W[u]lfstan owns me'. The Nuffield strap-end brings to mind the famous Alfred Jewel, also from Somerset and now in the Ashmolean Museum (accession number 1836p.135.371), which has the inscription 'AELFRED MEC HEHT GEWYRCAN' – 'Alfred ordered me to be made'.

After going through the Treasure process, the Nuffield strap-end was acquired by Oxfordshire Museums Service.

The Alfred Jewel.
(AN1836p.135.371)
(Ashmolean Museum,
University of Oxford.
Reproduced with kind
permission.)

Copper alloy strap-ends
from Oxfordshire (ninth to
tenth century). Note the
animal head terminals. The
strap-ends are 39 to 60 mm
in length.

71

This incomplete copper-alloy dagger scabbard chape from Warborough dates from the time of the Norman Conquest. Broadly rectangular in plan, the chape is missing the reverse plate and the long arm that would have been attached to, and supported, the scabbard sheath. The chape is openwork and depicts a knight wearing a helmet and long tunic and carrying a kite-shaped shield and large battle axe, leading (or possibly riding) a horse. The shape of the shield strongly suggests the figure is a Norman knight. The horse bridle can be seen as can one of the figure's hands holding the reigns, but the head of the horse is now worn beyond recognition. The soldier has his head turned sideways and crude facial features, including large round eyes, can be discerned. The reverse of the chape would have depicted a different motif, possibly a hunting scene showing an archer or huntsman standing next to an animal (possibly a deer or a fox, or a hunting dog). Only a small number of these chapes are known, with ten recorded on the PAS database. Of those, two are from Oxfordshire (see also BERK-2C6116 from Cassington).

Anglo-Norman scabbard chape from Warborough, 36 mm high with a width of 35 mm.

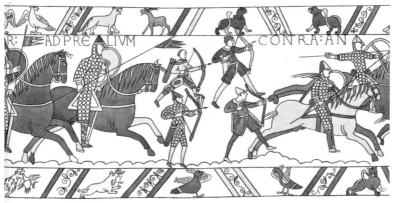

Scene from the Bayeux Tapestry depicting Norman horsemen and archers. (Charles Stothard illustrations, published 1823.)

Chapter 7
The Medieval Period (AD 1066–1500)

Oxfordshire's, and especially Oxford's fortunes were to rise and fall during the Medieval period. Founded in the ninth century, Oxford was expanding, and for the first time most urban development was planned rather than haphazard. On the edge of the town, near the river, Oxford Castle was constructed in 1071 for William the Conqueror; the motte and St George's Tower survived the destruction by Parliamentarian troops during the Civil War and still stand today. The university colleges took advantage of the city's economic decline in the fourteenth century and became powerful institutions and landowners. Several monastic houses were located in Oxford, with Osney Abbey being the most powerful. Recent excavations for the new Westgate development revealed extensive remains of Greyfriars Friary (AD 1244–1538). Although in Berkshire at the time, the Benedictine Abingdon Abbey rose to prominence from the mid-tenth century. The biggest landowner in the county, the Abbey also held lands elsewhere and, as well as receiving rent from farm tenants, they were able to set market tariffs. Abingdon Abbey became the sixth wealthiest monastery in the country but was dissolved by Henry VIII in AD 1538.

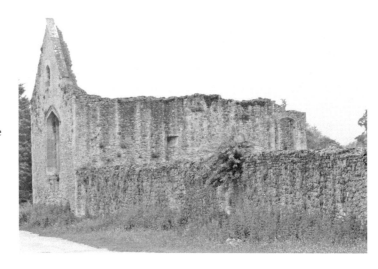

The ruins of Godstow Abbey, Oxford. The abbey was a Benedictine nunnery and was founded in around AD 1133 by Edith of Winchester. The surviving remains are Later Medieval. The abbey was dissolved during Henry VIII's dissolution of the monasteries and the converted buildings badly damaged in 1645 during the Civil War. (Paul Otter.)

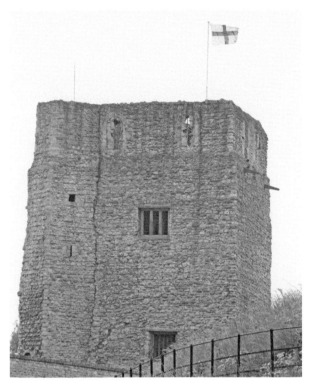

St George's Tower at Oxford Castle, built AD 1071–1073. The castle mound is in the foreground to the right. (Paul Otter.).

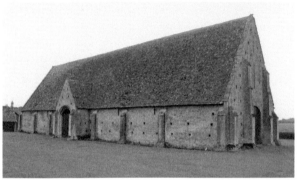

The thirteenth-century Great Coxwell Barn near Faringdon. (Paul Otter. Reproduced by kind permission of the National Trust.)

After finds of the Roman period, Medieval and post-Medieval finds compete annually for second place for the most recorded finds from Oxfordshire. At the time of writing there were over 4,600 individual items of the Medieval period recorded from Oxfordshire on the PAS database. Coins become more common from the later twelfth century in the reign of Henry II (AD 1154–1189), and coinage issued by subsequent monarchs increases in frequency. The 'long cross penny' issues of the Edwardian kings (Edward I to III, AD 1272–1377) are by far the most commonly recorded coins of this period. We see an increase in the production of dress accessories such as buckles, belt fittings and strap-ends from the thirteenth century onwards, while horse harness fittings and mounts also become more common. Artefacts with religious connotations, heraldic designs and personal objects such as seal matrices are often recorded with the PAS.

A seal matrix is used to make an impression on wax, acting much as a signature does on official documentation, such as charters and land deeds. The device of the matrix is cast or carved back-to-front so that when an impression is made the image appears the correct way round to the viewer. The PAS has recorded nearly 6,000 seal matrices, with over 5,000 being of medieval date. The vast majority are of copper alloy, and although comparatively rare, silver and gold examples are occasionally discovered. The majority are impersonal off-the-shelf matrices, many bearing religious scenes and inscriptions, attesting to their owner's piety. Others name the owner of the matrix, and occasionally their place of origin and occupation.

Identifying an individual named on a seal is most often impossible. This complete copper-alloy seal matrix found near Mixbury is an important discovery as the individual can be identified. The device depicts a kneeling figure (probably the owner of the seal) praying in front of a standing St John the Baptist, with the pascal lamb (*Agnus Dei*) in the field between them. The Latin inscription runs clockwise around the outer edge:

'S' PIS REGINALD LONDON[i] A P VII' ('the Seal of Prior Reginald of (or from) London')

As is often the case with matrices, words in the inscription can be abbreviated. For this matrix, the 'A' might go with 'LONDONIA', the letter 'P' might indicate 'Prior' and 'VII'

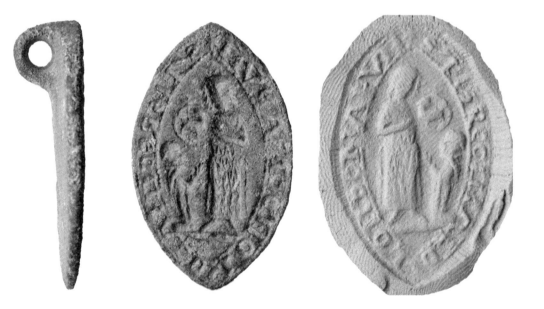

The seal matrix and impression of the seal of Reginald, seventh prior of Bicester Priory. The seal matrix is 39 mm high.

might suggest he was the seventh prior. London probably refers to his name and not to the place of the priory (John Cherry, formerly British Museum, pers. comm.). A man called Reginald is recorded as the seventh prior of Bicester Priory, who held the position from AD 1261 to AD 1268/69. The findspot for this matrix was only a few miles north of Bicester and it seems highly likely that Prior Reginald, or someone acting on his behalf, dropped the seal matrix while travelling to or from Bicester Priory.

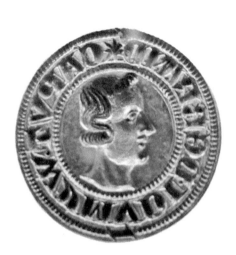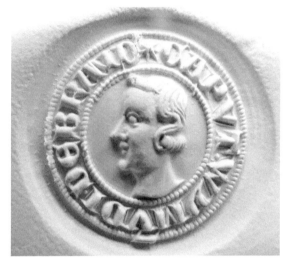

Silver seal matrix of Wymund de Brandon, clerk and attorney to the Abbot of Préaux (France) in *c.* AD 1279. The abbey had been granted lands by William I around Aston Tirrold, about a mile from the findspot near Cholsey. The inscription reads: 'CAPUT.WYMVDI.DE BRAND' – 'Head of Wymund de Brandon'. This seal matrix was acquired by Oxfordshire Museum Service after being declared Treasure. (PAS-657877)

This gold seal matrix is in exceptional condition and is of the highest quality; it is likely to have belonged to someone of considerable wealth. In the centre of the matrix is a dark green jasper intaglio, intricately engraved to depict a female in profile. The female wears a long veil about her head, with hair or possibly pearls visible above the forehead – the style probably imitating Hellenistic depictions of Ptolemaic queens (Martin Henig, University of Oxford, pers. comm.). The matrix has a personal legend in Latin around the outer edge, beginning with a six-pointed star:

'SIGILVM : SECRETI : hEN :' ('Secret seal of Hen'.)

The identity of the owner is uncertain; although 'Hen' is often assumed to be an abbreviation of the name Henry, the subject of the intaglio may indicate that the owner was actually a female (John Cherry, formerly British Museum, pers. comm.).

Women used seal matrices throughout the Medieval period, with oval-shaped seals the popular choice for women from the thirteenth century. The PAS has recorded many seals bearing women's names; some give a full name while others bear a first name followed by their mother or father's name, presumably indicating they were unmarried.

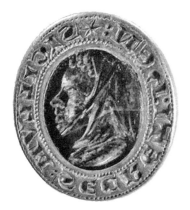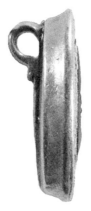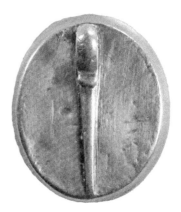

A gold seal matrix from Epwell. It is 18.7 mm high.

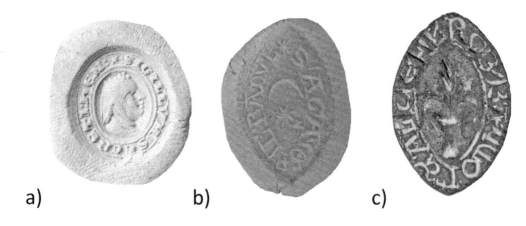

Impressions of seal matrices owned by women: a) 'Secret Seal of Hen', Epwell (BERK-2A91CA); b) 'Seal of Aga(tha) the daughter of Raoul', Spelsbury (BERK-B9DB25); c) 'Seal of Alice, daughter of Rob(ert) Ba[ri]cot', Clanfield (BERK-EE1AE5).

Dog lead buckles are objects of high quality and probably reflect the wealth of the owner. The multi-harnessing lead buckle and swivel for a dog's harness from Radley was the first complete example recorded. The object has buckles at either end for attachment to a strap, with a double-hinged openwork plate either side of a swivel loop. The swivel loop has debased zoomorphic terminals above the join. Now corroded in place, when functional all elements of the buckle would have allowed movement in several directions. Interestingly, the swivel loop is identical to tap loops recorded from late fourteenth-century contexts in London, suggesting that some objects identified as tap loops are actually dog lead swivels. A small number of other lead or strap buckles have been recorded with the PAS, including a much grander example in silver gilt from Suffolk (SF-3AD2BB). Dating from the late thirteenth to fourteenth century AD, the buckles were probably used on hunting dogs owned by noblemen, for whom hunting was a popular pastime.

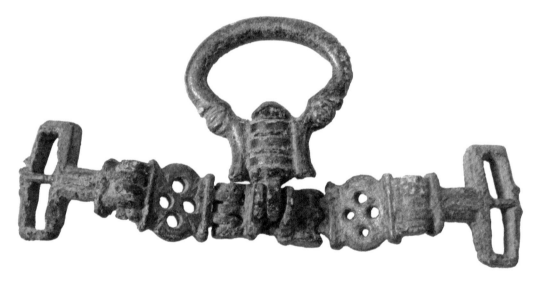

Dog lead buckle from Radley, 111.5 mm in width with a height of 54 mm.

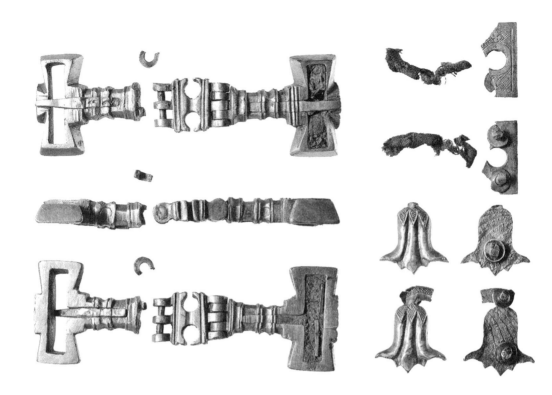

Silver-gilt strap fitting and associated mounts from Suffolk. (SF-3AD2BB)

Over 150 medieval horse harness decorations have been recorded from Oxfordshire by the PAS – they are not particularly common finds but a number have been recorded from Cherwell District. Made of copper alloy, many decorations come in the form of shield-shaped pendants, which were suspended from harnesses. Many bear heraldic devices (arms) of the knight or household to whom the horse belonged, but the arms cannot always be attributed to a named individual. Purely decorative, harness pendants served as a badge of identification and allegiance. It is likely that many pendants were lost while retainers or the knights themselves were travelling on business.

This early fourteenth-century harness pendant from Broughton bears the arms of Hugh le Despenser the Younger, born 1287 and died 1326. Inlaid with coloured enamel, the heraldic description of the arms is: 'Quarterly argent and gules, fretty or with a label of three points, over all a bend sable'. The label of three points shows that these arms were used by the eldest son. The label was removed after a father's death, but in the case of the Despensers, father and son died within a month of each other. Despenser the Younger married into the de Clare family and became very rich and powerful. He was constable and keeper of a number of castles, including Wallingford Castle, and was a favourite of King Edward II (AD 1307–1327), becoming the King's chamberlain and trusted ally. However, both he and his father (Despenser the Elder) fell from favour and were accused by the usurping Queen, her lover Roger Mortimer and others, of gross criminal behaviour. Despenser the Elder was hanged on 27 October 1326, his body cut up and fed to the dogs and his head sent to Winchester to be displayed on a spike. Despenser the Younger was also accused of high treason and was hanged, drawn and quartered on 24 November 1326. Edward II was forced to abdicate in favour of his son, Edward III.

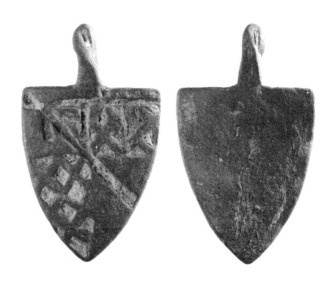

A heraldic horse harness pendant from Broughton. It is 49 mm high.

Left: Digital reconstruction of the arms of Hugh le Despenser the Younger.

Below: Heraldic harness pendants from Oxfordshire, left to right: (BERK-5A17C5) from Swerford; (BERK-6B4C1A) from Milton-under-Wychwood; (BERK-8A1FC7) from Bucknell.

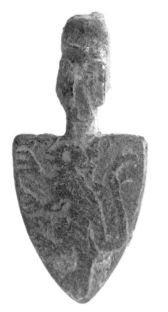
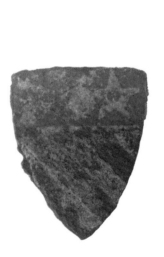
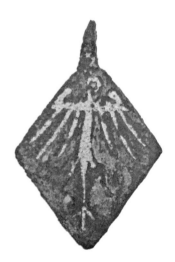

As metal detectorists usually discriminate iron when searching, iron objects are in the minority on the PAS database. Not all finders of archaeological objects are detectorists however; this iron 'forked' arrowhead, for example, was found by a lady and her children while out walking in woodland. They are quite rare with only three others recorded on the PAS database. Forked arrowheads were probably used for hunting birds and small game, as the findspot for this example suggests, but their use in war, specifically in regard to injuring horses, is also proposed.

The arrowhead has a circular socket for the shaft and projecting forked arms. The arrow would have rotated when fired and may not have caused a deep wound like a bodkin arrowhead but it would have torn skin resulting in a larger wound.

Arrowheads are very hard to date as many forms were in use for several hundred years – this example dates anywhere from the twelfth to sixteenth century AD. Archery was a popular pastime for all levels of society, as well as being the chief weapon in English (and Welsh) warfare. In 1363 Edward III proclaimed that every able-bodied man should use bows and arrows as part of his sporting leisure time, and that practice of other sports of 'no value', including football, quoits and cock-fighting, would be punished with imprisonment.

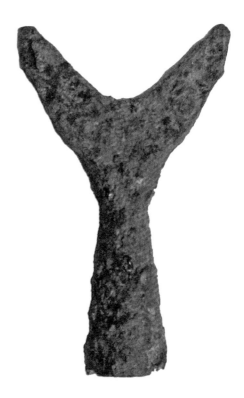

Forked arrowhead from Cornbury and Wychwood, 62 mm in length with a width of 39 mm.

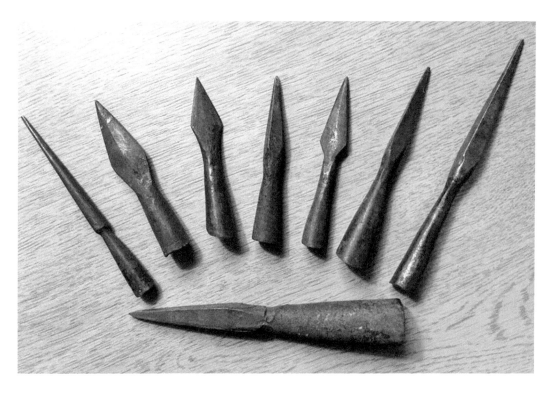

Reproduction medieval arrowheads. (Peter Forward. Reproduced with kind permission.)

This unusual cast copper-alloy flask is the only one of its type recorded from Oxfordshire by the PAS. The flask has a globular body with a narrowed neck and two small integrally cast lugs either side of the mouth. The base of the flask is rounded and therefore cannot be stood on a flat surface, adding to the interpretation that this flask is a travelling chrismatory – a set of three holy oils used in the medieval Catholic Church. These flasks come in a variety of shapes but all are small in size. The flasks could have been suspended by the lugs from a chain or strap and worn by the priest when visiting sick members of his community. The oils used were *oleum infirmorum* for the sick, *oleum catechumenorum* for baptism, and *chrisma*, or ointment, used for confirmation, ordination and certain consecrations.

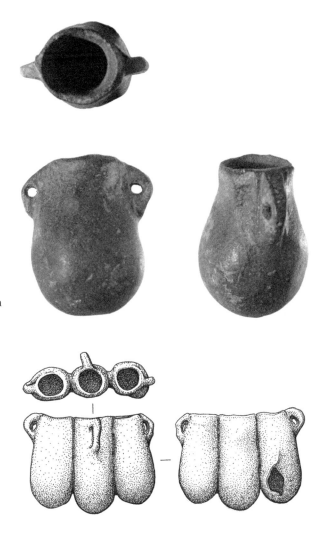

Chrismatory from Bruern, 39 mm high with a width of 28 mm.

This illustrated chrismatory from Dorset has three chambers for each of the holy oils. The chrismatory is 50 mm wide with a depth of 36 mm. (SOMDOR1735)

85

Going on pilgrimage was a popular activity during the Middle Ages, with all levels of society participating. There were shrines throughout England and on the Continent, often associated with a specific saint (for example St Thomas (Becket) at Canterbury or St Frideswide at Oxford). A way of showing piety in the hope of obtaining salvation, pilgrimage was also a form of tourism. Religious souvenirs were available to buy from most shrines. They came in the form of metal badges depicting saints or small lead flasks called *ampulla* that could be filled with holy water.

This pilgrim's souvenir badge from Milton-under-Wychwood depicts a mounted St George slaying the dragon. It is made from silver and gilded and, although incomplete, much detail survives. The horse wears a trapper, with a hole for the eyes, and the bridle is also visible, the reins extending towards the rider. St George is seated with his head turned to the viewer, revealing his full face and the armour covering his body. Folds of material or chainmail cover the forearm and strands of the rider's surcoat billow out behind the galloping horse. A stub projecting from the rider's shoulder represents the broken upper end of a lance, which St George grasps in his hand. The shaft of the lance extends diagonally across the shoulder of the horse but the lower part of the badge is missing. This would have depicted the horse trampling a dragon underfoot while St George slays it.

The cult of St George was closely associated with the Chapel of St George at Windsor, which was built by Edward IV (reigned AD 1461–70 and 1471–83) and Henry VII (AD 1485–1509). Pilgrimage to the chapel, where relics included the saint's heart and leg, reached a peak in the late fifteenth to mid-sixteenth centuries.

Because of the silver content this badge was reported under the Treasure Act 1996 and it was later acquired by Oxfordshire Museums Service.

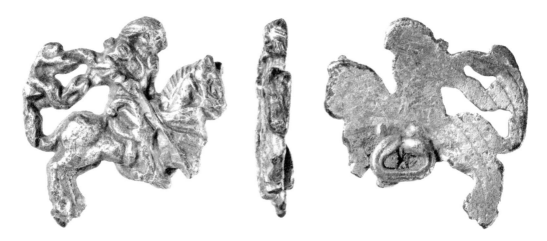

Pilgrim's badge depicting St George, from Milton-under-Wychwood. The badge is 22 mm long with a height of 22 mm.

Dragon Hill at Uffington, where local legend says George slayed the dragon. In fact there is no evidence that George ever visited England; after the Crusades his popularity as a warrior saint and martyr increased and the story of George and the dragon was widely adopted. (Paul Otter.)

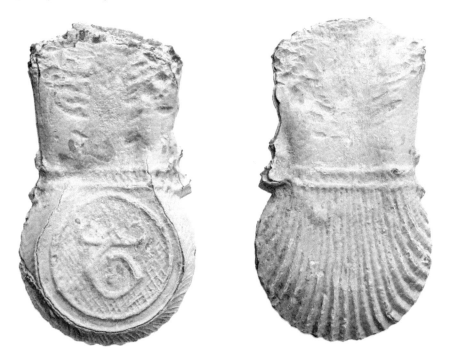

Pilgrim's *ampulla* from Northmoor. The Lombardic letter 'T' represents the cult of St Thomas of Canterbury while the scallop-shell design became a generic symbol of pilgrim saints and pilgrims. The *ampulla* is 53 mm high. (BERK-B472DC)

Chapter 8
Post-Medieval to Modern (AD 1500–1950)

46. The Asthall Hoard (BERK-oBBoEo)
Late Medieval/Early Post-Medieval (AD 1470–1526)

In August 2007 ground workers discovered a hoard of 210 gold coins while digging out a driveway. The coins date from around AD 1470 to 1526 and cover the reigns of Henry VI to the coinage reform of Henry VIII, from the Wars of the Roses to ten years before the Dissolution of the Monasteries. It is the largest hoard from this period. The coins are called *angels*, and their fractions *half angels*, as they depict the Archangel Michael slaying a dragon; a pious depiction, but one that may also relate to the overthrow of the House of Lancaster by York. Some of the rare coins were issued during Henry VI's second reign (AD 1470–1471) and by Richard III (AD 1483–1485). The hoard was worth a great amount in its day (£67 10s od). It has been suggested that the coins were hidden with the intention of recovery, possibly by the Church in advance of the Dissolution of the Monasteries under Henry VIII. Another suggestion is that it was hidden by a wealthy wool merchant, as the area around Burford, Witney and Chipping Norton became rich and prosperous because of the wool trade.

The coins were submitted as Treasure and were later acquired by the Ashmolean Museum (HCR8102).

Above: Some of the gold coins from the Asthall Hoard. (PAS/A. Byard.)

Right: One of the gold *angels* from the Asthall Hoard, 28 mm in diameter.

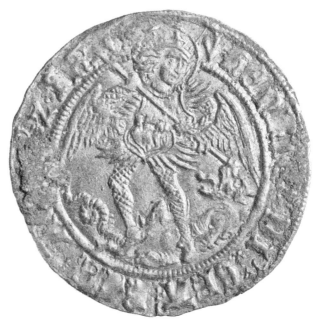

A rare survival from the ploughsoil is this pair of seventeenth-century silver spectacles. Although the glass is now broken and missing, they were found folded within their copper-alloy carry case. The spectacles have thin round lens frames with a scrolled Y-shaped bridge arm joined by a silver rivet, which enables the spectacles to be folded in half. This type of spectacle did not have any arms and would have been balanced or squeezed onto the bridge of the nose to keep them in place. The copper-alloy case is simple in design, with a rounded body and a sub-rectangular neck, where the outer edge retains a small fragment of a suspension loop. The walls of the case are complete to about halfway down; the lower half of the case is open and has suffered some ploughing damage.

Spectacles with arms were not introduced until the eighteenth century. Before then spectacles were awkward to use and would have been worn infrequently. They were generally associated with the elderly and infirm but demand for them increased from the later seventeenth century with the publication of the first newspapers. Silver examples like the pair from Clifton Hampden may have belonged to a wealthy and learned individual, such as a scholar or churchman. Why this pair and their case ended up in a field is unknown; they could have been accidentally dropped or have been mixed up in so-called night-soil manuring.

As these spectacles are made from silver, they and the associated case qualified as Treasure. They were acquired by the Oxfordshire Museum Service.

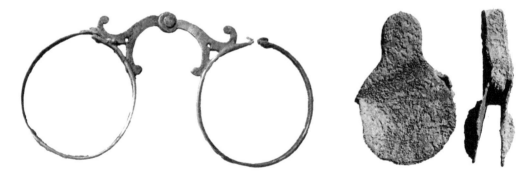

Silver spectacles and case from Clifton Hampden. The internal lens diameter is 31 mm.

48. Trade token from Cassington (BERK-331663)
Seventeenth century (AD 1658–1672)

Trade tokens are small, unofficial coins issued by town officials and private individuals between AD 1648 and 1672. They were manufactured locally in response to a dire shortage of small change. The majority of trade tokens were issued as halfpennies and farthings and are usually circular, but heart-shaped, octagonal, and square or diamond-shaped tokens are also known. Trade tokens usually state the name of the issuer and the name of the town or village where they were based. They sometimes give the issuer's occupation or a guild's arms, and the date of issue. With the help of contemporary records, detail about the issuer's life can often be found.

This lovely copper-alloy farthing trade token found in Cassington was issued by William Morrell of the Crown Tavern in Oxford. William Morrell is recorded as a vintner in 1659, but he also worked as an ironmonger alongside his wife, Anne Thurton, whose initial appears in the legend on the token (Anne was also one of four Oxford women who issued tokens in their own name). Morrell took over the wine licence from his wife in 1658, so the token could only have been issued after this time.

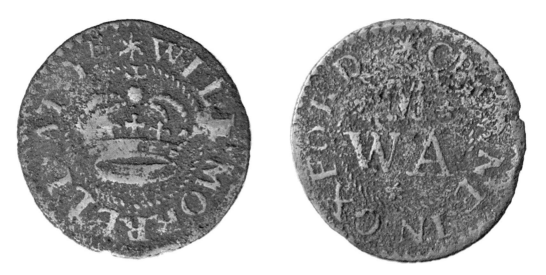

Oxford farthing trade token, 17 mm in diameter, reading: WILL MORRELL AT YE / CROWNE IN OXFORD W.A.M.

The Crown Tavern was located at 3 Cornmarket in Oxford and is currently a Vodafone shop. Internally, behind the Georgian façade, the building retains many period features, including the 'Painted Room' where William Shakespeare is thought to have stayed on several occasions. This room is occasionally opened to the public during the city's 'Open Doors' events. The Crown appears to have closed as a tavern in the early eighteenth century.

Many trades are represented in the Oxfordshire (and old Berkshire) tokens: apothecary, baker, brewer, chandler, clockmaker, cutler, clothier and draper, fishmonger, glover, goldsmith, hatter, hosier, ironmonger, mercer, milliner, rugmaker and watchmaker. Public houses often feature, many of which no longer exist. Around forty-two towns and villages issued tokens in what is now Oxfordshire.

Trade tokens were finally banned by Royal proclamation in AD 1672 with the reintroduction of official state coinage of the same denominations.

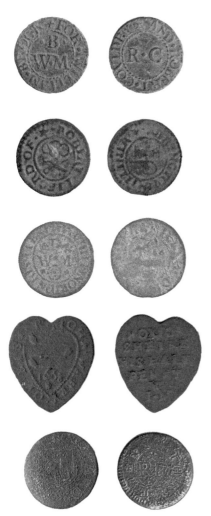

Trade tokens from Oxfordshire, from top to bottom: William Broock and Robert Couldry of Dorchester (BERK-C5220E); Robert Liford of Abingdon (BERK-F816FA); William Diston of the White Hart, Chipping Norton (BERK-6664AD); Heart-shaped token of John Warry of Bicester (BERK-EF59C8); Richard Rastell of Thame (BERK-58CCE0).

Many late post-Medieval artefact types are still very common today. As such, the PAS tends not to record many objects that post-date AD 1700. There are some types of artefacts we encouraged to be reported, like the seventeenth-century trade tokens. Another class of period-specific artefact is the pipe tamper, used to compress tobacco in the bowl of a clay pipe and so ensure the tobacco would burn evenly.

Tobacco was introduced to England from America in the sixteenth century and was smoked in clay pipes. Fragments of clay pipes are frequently found and alone they don't tell us much, but decorated pipe bowls and pipe tampers are more useful in socio-economic and cultural studies. Pipe tampers were manufactured from a variety of metals, as well as wood and bone. They can be plain rods or elaborately decorated affairs like this example from Somerton. Dating from the middle eighteenth to early nineteenth century, the top of the tamper depicts two men boxing on an uneven platform with the moulded stem of the tamper projecting below. Pipe tampers of this period could have been used with the newly introduced 'churchman' pipe – a very long (and therefore brittle) clay pipe up to 90 cm in length. Short pipes remained most popular, however, and some had very elaborate mouldings. Cigarettes, cigars and wooden pipes took over the market in the early twentieth century and clay pipes mostly went out of use by the 1920s.

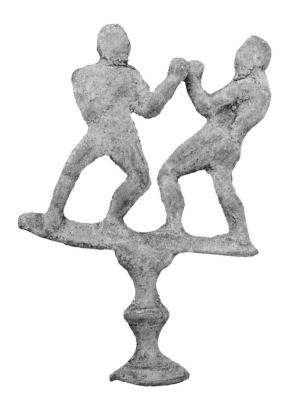

Boxing men pipe tamper from
Somerton. The tamper is 64 mm
high with a width of 43 mm.

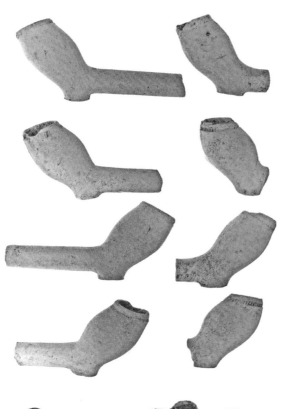

Late seventeenth and eighteenth-century plain clay pipe bowls.

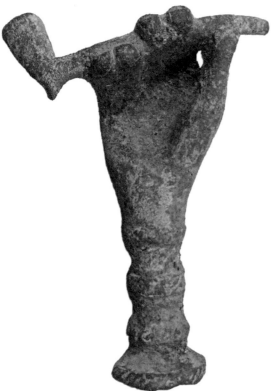

Pipe tamper from Yarnton, 48.5 mm high with a width of 38 mm. (BERK-2D6663)

Continuing to record past AD 1700 is usually reserved for items of potential Treasure (over 300 years old), objects that are unusual, or objects that relate to a specific event or tell a certain story. My final choice for this book is a three-sided aluminium case from Moulsford, of recent date but still of great interest. The case is probably a matchbox holder and dates to the latter period of the First World War. An example of 'trench art', the object was probably fashioned from a mess tin. One side of the holder is decorated with a symmetrical foliate design with leaves and flowers. The other side has a pair of crossed rifles with the Union Flag and the American Stars and Stripes flying from the ends of the barrels. Above the crossed rifles is a crown with lines radiating from it. The crown separates the words 'WORLD WAR', while on the spine is the word 'YPRES'. The Belgium town of Ypres was under almost constant bombardment throughout the First World War. It is estimated that over 450,000 men died in the Ypres Salient during the campaign. The Americans joined the campaign in 1917, so this item is likely to date from 1917–18.

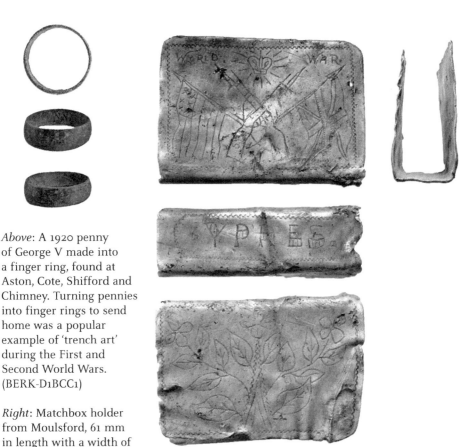

Above: A 1920 penny of George V made into a finger ring, found at Aston, Cote, Shifford and Chimney. Turning pennies into finger rings to send home was a popular example of 'trench art' during the First and Second World Wars. (BERK-D1BCC1)

Right: Matchbox holder from Moulsford, 61 mm in length with a width of 42 mm.

Further Reading and Research

All of the finds featured in this book and the other 30,000-odd finds recorded from Oxfordshire are freely available to view on the PAS database – ww.finds.org.uk/database. You can search by period, artefact type and region/parish. Findspot locations are automatically restricted to a four-figure grid reference (1 km square). The website also provides information on the Treasure Act 1996, suggested research projects, contact details and how to get involved.

Below are a handful of book recommendations that are a good starting point for the interested reader:

Allason-Jones, *Artefacts in Roman Britain* (2011, Cambridge University Press).
Blair, *Anglo-Saxon Oxfordshire* (1994, Sutton Publishing).
Henig & Booth, *Roman Oxfordshire* (2000, Sutton Publishing).
Moorhead, *A History of Roman Coinage in Britain* (2013, Greenlight Publishing).
Williams & Naylor, *King Alfred's Coins; the Watlington Viking Hoard* (2016, Ashmolean Museum).
Thames through Time (three volumes), Oxford Archaeology/Thames Valley Landscapes Monograph.

Local archaeological and historical research is published in *Oxoniensia*, the annual journal of the Oxfordshire Architectural & Historical Society, and in the Council for British Archaeology South Midlands journal, which is also an annual publication.

Oxford Archaeology has a published a number of monographs based on its works across the county. These are available from their website: www.oxfordarchaeology.com

The county's museums hold archaeological archives spanning all periods, which are available for consultation. For further information contact Oxfordshire County Council's Museum Resource Centre at Standlake and the Ashmolean Museum in Oxford.

Oxfordshire's Historic Environment Record holds details of all known archaeological and historical sites in the county. More details can be found here: https://www.oxfordshire.gov.uk/cms/content/historic-environment-record

Oxfordshire County Archaeological Service's Historic Landscape Characterisation project, funded by Historic England, provides a map and database detailing the historic and archaeological processes that have influenced the county's modern landscape. More information can be found by visiting: https://www.oxfordshire.gov.uk/cms/content/oxfordshire-historic-landscape-characterisation-project

The University of Oxford's Institute of Archaeology and the Department of Continuing Education offer full and part-time courses in archaeology.